Colour and Abstraction

GEORGE BLACKLOCK

THE CROWOOD PRESS

First published in 2015 by
The Crowood Press Ltd
Ramsbury, Marlborough
Wiltshire SN8 2HR

www.crowood.com

© George Blacklock 2015

All rights reserved. No part of this publication may be reproduced or transmitted in any form or by any means, electronic or mechanical, including photocopy, recording, or any information storage and retrieval system, without permission in writing from the publishers.

British Library Cataloguing-in-Publication Data
A catalogue record for this book is available from the British Library.

ISBN 978 1 78500 031 7

Photography
All photographs of finished paintings by George Blacklock are courtesy of Flowers Gallery; all photographs in the tinted section Media Tools and Techniques in Chapter 5 are courtesy of Katherine Blacklock; all other photographs of studies and images are by the artist.

Dedication
To George, Katie, Ruth, and Harry

Acknowledgements
I would like to thank Matthew Flowers for his and the Flowers Gallery's support in this endeavour, most especially Juliette O'Leary, who was fabulous. I would also like to thank my exceptionally talented daughter Katie, who took the photographs in the section 'Media, Tools and Techniques' in Chapter 5, and many others besides that we did not use. Also all the Blacklock clan for their support. And the University of the Arts London and Chelsea College of Arts in particular – especially the ever-patient Alex Madjitey and Betty Borthwick.

Typeset by Sharon Dainton Design, Stroud.
Printed and bound in Malaysia by Times Offset (M) Sdn Bhd.

Colour and Abstraction

CONTENTS

Preface		7
Introduction		9
1.	The Picture Plane and Pictorial Space	11
2.	Drawing into Abstraction	27
3.	Landscape, Body and Mind	33
4.	Systems, Grids, Fibonacci and Phi	53
5.	Paint as Stuff	69
6.	Working in Series – The Pietas	85
7.	Gesture and the Theory of Joints	91
8.	Transcription and Abstraction	95
9.	The Use of Studies	105
10.	Inhumanities and Humanities	117
11.	Working Towards a Final Solution…?	133
Afterword		140
Index		141

PREFACE

Thinking through Making

This book is not about getting you to paint like me, or even to think like me. We are all gifted with our own thought patterns and spirit – these manifest themselves in our personalities, and these differences are rewarded in painting with what is often called our 'style'. Even when we try to adopt another style of making, we cannot help but make it our own, so you don't have to worry about creating your own style because we do that naturally – it really is (either fortunately or not) our default position.

One of the truths about abstract painting is that intentions are often compromised and frequently improved on, by the act of making. So it is most important that you are both vigilant and persistent – these are the most important qualities to have if you want to make successful paintings.

The thoughts and pictorial ideas I have when I start a painting become enhanced by what I learn during it. I believe that if I do not learn, I don't make an interesting painting. Making paintings that simply demonstrate what you know, may impress initially but real ideas are always about what you have learned 'on the journey'. It is important that you concentrate your mind whilst painting so that you are 'in the present' and not thinking about what you would like the painting to be like, or regretting what it could have been like. Sometimes your inner mind, through its familiar interaction with the materials (and this constant interaction with the same kind of materials is an undoubted strength of painting), overrules what is in the front of your mind. On every occasion I have noticed this happening, it has always been for the better, and I have learned, and thus improved, as a painter and an artist.

The irony of this is that repeating 'what worked last time' never seems to work – so you adapt and move on. The fruit of your labours will attest to the rigour of your learning. Paintings thus become the product of your thinking (thinking through making). The exciting thing about making paintings (and other art objects) is that how you think and how you feel, is made real through an art object here in the world!

LEFT: *Ancestral Voices 5.* (Studio shot)

INTRODUCTION

I once watched a film of Picasso painting a picture, I think it was on glass, and I noticed that every time he made a mark he made it with absolute conviction. It was as if each mark were the final statement, even if he changed his mind (which he did a lot). I thought this was a real lesson to anyone wishing to make paintings now – that each mark you make has to have this level of conviction. Hesitant marks and decisions don't work – they only produce hesitant or half-finished pictorial ideas. So as a matter of course, when you make your work either from the exercises in this book or in your own work, please make them at 'full throttle'. To allow this you will have to ensure the following three things:

First, that the surface you are painting on is smooth and able to take the paint. If you are priming your own canvas, make sure you sand between coats to ensure the surface will be as smooth as you can get it. A rough or bobbly surface will interrupt the flow of your brush and consequently your thinking.

Second, be sure that you have mixed up enough paint to do the job richly. There is nothing worse if you are in 'the moment' when painting, to run out of the exact colour and exact consistency of paint. The result is always a bodge job, and looks it.

Third, make sure you are using the right-sized brush for the job. If you need to cover a lot of ground, and you feel bored just in covering the space, use a bigger brush!

The size and type of brush you use (or scraper or squeegee) is something you will have to feel for yourself, which is why there are no definitions of brush types in this book – any art shop will supply you with a list of brushes and their uses. I often use decorators' brushes as they can hold a lot of paint, and I think you will find they may have to in order to create the richness of experience you want from your paintings. But no matter what sort of brushes you use, always use the most expensive you can afford, because the more expensive they are, the less they are likely to distribute hairs in your paintings.

So finally, paint with as much conviction as you can muster – no half-hearted measures.

LEFT: *Pieta*.

CHAPTER 1

THE PICTURE PLANE AND PICTORIAL SPACE

To discuss paintings, and particularly abstract paintings, I feel that I should first introduce the concept of pictorial space. This is the space that is realized within the rectangle of the canvas. This can be infinitely deep or as flat as the surface you are using. The invocation of pictorial space requires in turn an idea that has come to be called the 'picture plane'. The picture plane is the actual or perceived front of the painting, and it sometimes appears to be made of glass through which you see a representation of the world or the front of a physical object.

If, for example, we are drawing a straight railroad line into a distant horizon, the space we create is measured from where the surface of the canvas begins to the depth created by the illusion. This starting point is called the picture plane. Pictorial space is what happens beyond and across this plane.

The use of perspective creates depth in our drawing (in this case 'one point' perspective, where everything recedes to one 'vanishing point' on the horizon). The interesting thing about horizon lines is that they always occur at eye level: in other words, when looking at a drawing like this we measure where we are in relation to what is depicted in the picture. This is important to understand because this is also a tool of the abstract painter.

If the horizon line is higher, it feels as if we are lower to the pictorial space – as if we were sitting or kneeling, and looking up into the pictorial space. If it is low, it is as if we were in a building higher up and looking down.

This is all well and good for traditional 'depictive' paintings that we have come to understand through the work of artists

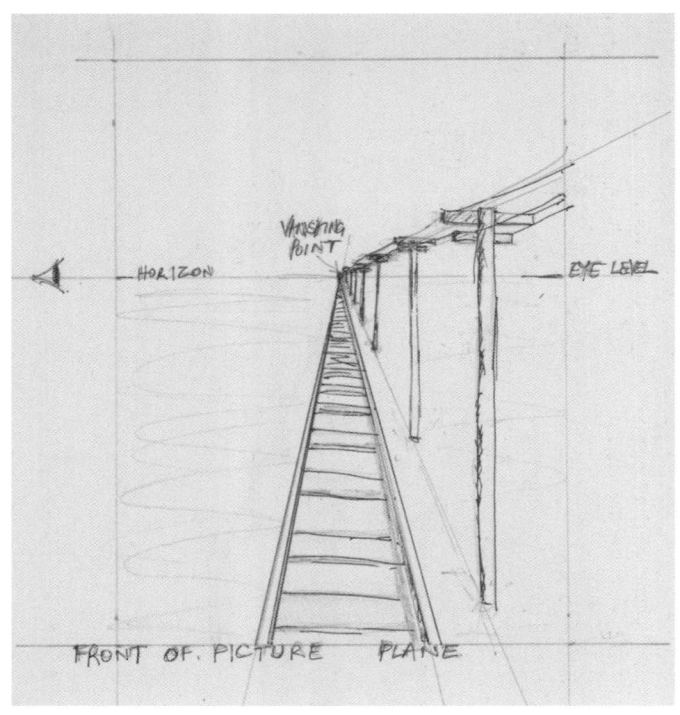

In this quick (and cock-eyed) sketch of a railway line, two things are apparent: a sense of space within the picture, and a feeling of where you are in relation to that space – you could be in the cab of a locomotive.

LEFT: *Intimacy.*

THE PICTURE PLANE AND PICTORIAL SPACE

We are sitting in a building across the road from the red building and opposite the chair in this room space; we can see the top of the chair seat, but under the lamp.

THE PICTURE PLANE AND PICTORIAL SPACE

The coloured shapes here are relatively near or further away from the 'picture plane'; some seem more advanced towards us than others.

made since the Renaissance in Europe, and latterly through our understanding of photography. In fact we are very sophisticated regarding this kind of pictorial awareness, so much so we sometimes forget that we have it.

In the rich history of European painting we are used to seeing that pictorial space is established through an understanding of perspective – similar things, such as lamp-posts or trees, are smaller the further away they are. Colour was always used in these paintings to support this recessive quality of space. In Renaissance times painters declared space through a perspectival drawing structure (what I call a 'here to there' effect), but this was always reinforced through aerial or colour perspective. Atmospheric effects are realized through the use of the natural spatial properties of colour, how it advances towards or recedes away from the picture plane. We have all experienced these spatial effects when trying out different colours on our walls for interior decoration choices.

The Mona Lisa

In the case of a famously 'real' depiction, Leonardo's *Mona Lisa*, the distant hills are made 'real' through the green/blue tint applied to the drawn landscape.

If we look at the Mona Lisa we will see that the mountains and hills in the background of the sitter (*La Giaconda*) are painted in a sort of faded blue/green series of tints, whereas nearer the

I have reproduced the blue/green tints of the landscape behind *La Giaconda* in this collage, as you can see from the left panel. Once the collaged photograph of the figure is set in the picture you can see the background sits very comfortably behind the figure, in effect throwing the figure forwards.

THE PICTURE PLANE AND PICTORIAL SPACE

foreground Leonardo makes use of richer and bolder colours and tones. This adds to the pictorial space that Leonardo is creating in his work.

If you look at distant mountains in the landscape, they appear to have a 'thin' green/bluish tinge. In most landscape paintings you will see this applied to declare pictorial space with what has been called variously atmospheric colour, or aerial perspective. The distant hills/mountains in these paintings are nearly always painted in blues and greens to establish a sense of recessive space in the background of the painting. The way that colours react to each other in this way (relative to each other in terms of pictorial space) is a fundamental aspect of paintings dating from the last half of the nineteenth century when impressionism emerged as a formidable presence in the European art world.

Once artists were able to purchase oil colour, ready mixed and in (portable) tubes on a more commercial level, they could work outdoors in the natural light of the world they were depicting. And this in turn led to colour becoming a clear focus for their invention around the 'usual' rules of declaring pictorial space.

Fauvism

Having understood the role that colour played in traditional paintings, the Fauvists ran riot against all the rules that had been carefully ordered to reproduce a kind of space that would fool the eye into believing the space in these paintings was exactly like the world we see outside. The paintings the Fauvists made, through a more playful use of colour (relative to this traditional use), were exhibited and received with alarm by the critics and public at the time – resulting in the name we know them by today ('fauve' translates as 'wild cat' from the French).

The first thing you find when looking at a Fauvist painting is

In this seascape I have deliberately used vibrant colour throughout, and this 'throws' the drawing structure so there is no sense of a 'here-to-there' believable space. As a real depiction the whole image sits uncomfortably: instead we are treated to a colour fest where the real subjects of the painting are the colour harmonies and dissonances. This is an exercise that you can play with to see what alternative kinds of space and moods can be created through using this method.

THE PICTURE PLANE AND PICTORIAL SPACE

that there is no sense of believable space. There are houses and trees and rivers detectable in their paintings, but they are signs and signifiers, and there is no attempt to 'fool the eye'. If you try and paint a landscape within this method you will find that there are areas of space that do not 'feel' right compared to what we know about space. In this way the Fauvist painters disconnected colour from its role in supporting the depiction of a believable space to become increasingly the subject of the painting. In doing this they created a new focus for, and construction of, pictorial space.

Although I have used Fauvism as a focus of this phenomenon for the purposes of this book, in truth Fauvist painting is the product of a gradual process of interests and development (learning) in the use of colour from Manet through impressionism to the post-impressionist paintings that predate them. Vivid signposts to this 'release' of colour from its subordinate role are found in the work of Gauguin and Van Gogh.

Once this particular hare had been set running, the idea of questioning the role of all aspects of pictorial convention was inevitable. The focus of artists in the twentieth century became much more on increasing invention. In other words, artists developed the habit of asking the question 'why not this?' – an approach which led, inevitably, into abstraction: why does painting have to depict anything other than itself?

Henri Matisse was a noted Fauvist painter, as indeed was Georges Braque. The work they did following this explosion of colour was vital to the development of painting in the twentieth century. Braque then focused on the drawing structure within the newly established 'non-natural looking' pictorial space – why have perspectival space at all? He was a significant member of a group of artists, including Picasso, who invented a new structure to pictorial space we now call cubism – and cubism, as we shall see in the next chapter, is another significant signpost towards abstraction.

Matisse concentrated specifically on the role colour could play in creating a tension with the declared drawn space (he would still use fairly conventional drawing structures in his landscapes and still lives). He wanted his colour to undermine the, by now simplistic, 'here to there' intention of the space receding from the picture plane. His use of colour creates a tension in what the drawing wants to do with what the colour wants to do, and a major part of Matisse's work focuses on this creative tension.

Moving towards Abstraction

Hans Hoffman (having emigrated from Europe to America) was influenced greatly by this aspect of Matisse's work; his work focused on what he famously called the 'push and pull' effect to describe the creative tension in his use of colour in his paint-

The coloured squares in this study after Hoffman all hold differing positions relative to the front of the picture plane. Although some are seemingly behind others, they are pushing forwards from what seems their 'logical' position. Thus the blue in front of the orange is being 'pushed' forwards: although its natural colour space is behind the orange, it appears to be in front. This creates a pictorial tension, and colour used in this way is an example of what Hoffman called the 'push/pull' of pictorial space.

ings. However Hoffman, influenced also by the reorganization of pictorial space typified by the cubist work of Picasso and Braque, did not use perspectival drawing at all: he used completely abstract shapes, often utilizing rectangles of overlapping colour on boldly coloured grounds. So we have arrived at a significant level of abstraction, and this will be a good point at which to try and understand more about the relationship of colour to abstract pictorial space.

Internet search
Look up Fauvism; Georges Braque; Henri Matisse; Hans Hoffman.

On the following pages you will see exercises in looking at the way colour 'sits' in space relative to other colours; try this out yourself within a basic range of shapes and drawing structures. Most of these exercises are done on a small scale – postcards are

■ THE PICTURE PLANE AND PICTORIAL SPACE

good for a lot of them — although you will find that as you modulate the ground colours you will need to invest in watercolour paper or pads.

I have tried to point out how other abstract painters have developed these properties of colour in their own work through the further study indents. Please utilize the internet to get an idea of these works, but wherever possible look out for these artists in museums and galleries.

Purposeful Play

Before you embark on these exercises, you must be cognizant of one of the most important tools in any abstract artist's toolbox: the ability to be able to take part in play — but the purpose of play is always to find something out. This purpose requires that you are able to let your imagination run, and also that you are extremely vigilant. Play is never wrong, and in fact should be cultivated and implemented even in the direst of situations, but the ever-present twin of purposeful play is extreme vigilance. Vigilance and play are to be cultivated, and one of the great things about painting is that as you make, you learn more; and as you learn more you become increasingly vigilant.

Exercises

In this section we will take a series of colour-block exercises.

As you will see, colours occupy a different space when seen next to one another: some colours advance, others recede relative to each other in a white-ish space. It becomes clear that, as in our Fauvist landscape, colour juxtaposition can create a creative tension between natural colour space (how colours advance and recede) and the drawing structure of your painting. In other words you can create a clash with what you know to be true, and the illusion created by the colour. A general rule in trying to understand colour space is that paler, cool colours recede, and stronger, warmer colours advance.

It is worth noting here that colour responds differently on a coloured ground to when it is on a white ground. The role of white changes things completely, and instead of having a situation where on a white ground it is impossible for a colour to be lighter than it, so all colours used are darker than the ground. When we use a coloured ground, we have a use of colour space that I think has more depth; it certainly feels rounder and more spatial (and less harsh). On a coloured ground, any shapes or marks in white are active elements within the pictorial space, rather than the restrictive static role of the ground colour.

These are just postcard-sized exercises and play — you can do

This one is simple: paint blobs of different colours with space between each on a white card. Note how they all appear to advance or retreat in an imaginary space next to each other: this is the natural 'colour space' of each hue.

your own set of these to learn more about how colours relate to each other: this could be an endless series of cards — all artists have made notes to themselves in exercises such as these, they help in creating their work, so please don't underestimate the work done here.

Vary these exercises yourself, for example looking at the same colours but different types — cadmium yellow with a lemon yellow... or wildly different tones and hues — let yourself go.

Of course you do not have to be in any way restrictive, and in fact you will find that once the genie of unrestricted colour is out of the bottle, abstraction came out too.

I do not exclude black from any discussion of colour, mainly because black can be modified so that it has varied colour tones within it; a greenish black or a reddish black can still operate as a black in any picture, but still have a colour relationship to those around it. You can also mix a black through mixing primary colours in varying quantities, or more easily by using viridian green and alizarin crimson (having Prussian blue and a yellow handy for variables). So I do not see black as a non-colour.

THE PICTURE PLANE AND PICTORIAL SPACE

To play with this further I have collaged a series of blocks of colour next to each other in the white space of a sheet of paper (you can do this on white primed canvas if you wish). When you try this exercise you will discover the need to vary what can quickly become a dry and academic process.

Having looked at very geometric possibilities, no matter how compromised by colour and what we do with it, it seems appropriate we should look at exercises that allow us a more fluid use of colour. In some cases the very composition of the painting can be dependent on the fluidity of the paint, although limited by the architecture of the process. Instead of bars or rectangles of colour, we can pour paint on to the surface so that it finds its own form through gravity. This can be organized rigidly or more fluidly, dependent on your orchestration skills when faced with the cussedness of a fluid medium and how it collaborates with gravity.

Remember when you are making your studies that there are no definite rules. There is a very practical dictum related to making abstract paintings derived from something I have created from comments by artists from Picasso to Willem de Kooning: 'Once you think you have established a rule, there is no alternative other than to try and break it.' I think these should be the watchwords around 'purposeful play'.

Internet search
Look up the work of Ken Noland; Bridget Riley; Frank Stella; Ellsworth Kelly; Morris Louis; Helen Frankenthaler; Ian Davenport.

▪ THE PICTURE PLANE AND PICTORIAL SPACE

It is worth playing with this to see what I mean, so let your imagination go with different colours in differing sizes on differing coloured grounds – as you can see here, I have created three versions (and uses) of the primary colours: red, yellow and blue.

THE PICTURE PLANE AND PICTORIAL SPACE

Here, the white clearly advances in front of the darker colours around it. I find that using a coloured ground creates a different quality of space, and in this space white becomes an active character.

Now that we have looked at colour on white grounds and then on coloured grounds, it is possible to play further with this simple drawing structure of rectangles of colour on a ground. In these exercises I have looked at how colours react to differing ground colours, and then started to modulate the ground with different tones and colours around the rectangles to see what happens when I adjust the colour and marks around the rectangles – and how this affects the way the rectangles sit in the picture space. It is also worth noting here how the space has a different feel, less a given and more a created space with the touch of the hand visible. I call this a 'tactile space'. Try this with differing grounds and differing coloured rectangles. Play and play again with it.

■ THE PICTURE PLANE AND PICTORIAL SPACE

In these studies I have played with the role of different colours relating to the space where they seem to 'settle', relative to their size and shape. As you can see, each painting offers a differing sense of space due to the lightness and density of the colour in the backgrounds and in the rectangles. It is obvious that there are hundreds of alternatives, so even with this drawing structure (of floating rectangles) you can work through many alternative colour schemes, which will give you experience of differing palettes of colours.

THE PICTURE PLANE AND PICTORIAL SPACE

You can, of course, get the rectangles to meet and/or overlap. This will create further tension between what the colour wants to do and what the pictorial structure will let it do. Again I advise you to expand on this exercise to vary the tonality and density of hue to see what works best in terms of colour harmony, and what works best in terms of colour dissonance. By creating this closed world of relationships with the rectangles, the tension between each is heightened as if each wants to pull or push against the join with the other.

If you lean the rectangles together, you will find that they run off the edges of the ground and form a more diagonal cut into the space. This offers another dynamic to your pictorial space. See how close to the edge the point of the resultant V shape (or chevron) ends: this creates more (or less) tension to that shape in that space. In these instances the softer ground seems to work away from this dynamic so feels more unresolved than the 'hard-edged' approach.

■ THE PICTURE PLANE AND PICTORIAL SPACE

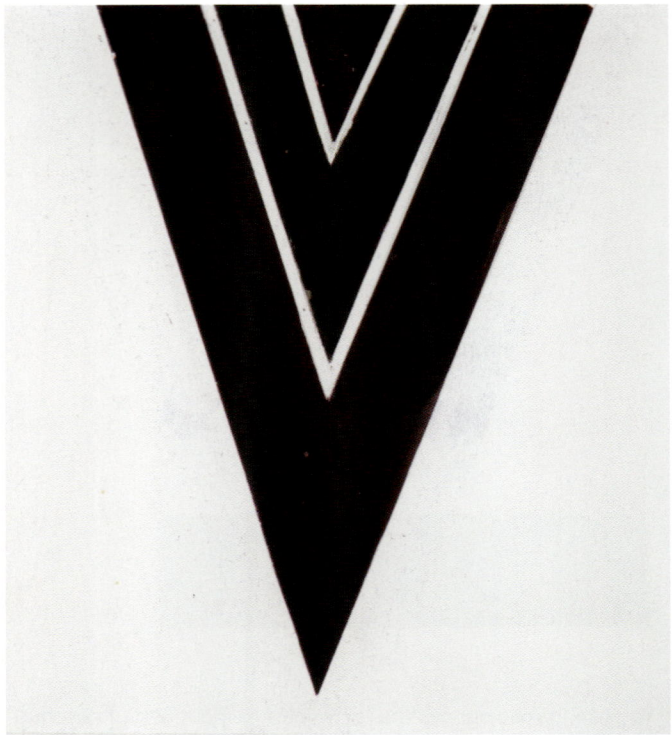

When the chevron is isolated in a white space, then it provides a more substantial presence whose identity can be changed through varying the colour and density of hue. In these examples I have contrasted primary colours with mixed (coloured) black tones. They 'sit' in the space differently relative to the density, size and placement of the colour. So again, it is advised that you run through more possibilities than you find here.

THE PICTURE PLANE AND PICTORIAL SPACE

I have used a collage of pre-painted card/paper for these exercises: this allows a lot of freedom to try differing combinations before settling on each composition; then you can glue the shapes down. You can also change your mind then and paste another colour over the top. It is a lot of fun and you can get lost in this. Make loads of these – each one will teach you more about how colours react with each other, and the relative lack of incident and detail means that you are dealing with colour space quite directly.

The first of these exercises uses the cut-off pieces of the chevron studies; put together they create another shape that can be useful. The second is a series of strips of the black tones covering the whole surface. Stripes have often been used by artists to focus on the colour/tonal relationships through reducing pictorial incident to a regulated form. We could equally make loads of stripe paintings, as we have done with the chevrons. Again, this will offer you plenty of options to test colour relationships.

23

■ THE PICTURE PLANE AND PICTORIAL SPACE

24

THE PICTURE PLANE AND PICTORIAL SPACE

Instead of leaning rectangles of colour, in these two studies I have poured strips of paint. Again there are many variants to be found in these exercises, so if this is an area you are more interested in than the more rigorous structures mentioned earlier, then please extend the possibilities as you go on. Pour from the middle out, pour sheets of colour on top of each other so that you achieve a glaze of four colours: it is up to you.

CHAPTER 2

DRAWING INTO ABSTRACTION

Having looked at the way colour broke away from its traditional role of supporting the drawing in making pictorial space, what of drawing? Once colour was freed up from this traditional role in depiction, it set a whole series of hares running. It is interesting to look at what artists did with drawing within pictorial space following this separation.

The first thing that happened was that traditional pictorial space was ripped asunder and a new sense of space became interesting to artists. I think how this came about can be reduced to a further question made about painting: how do we represent what we know about the world in our paintings as well as what we see? This is particularly crucial to those artists inheriting work of the calibre of the impressionists (for example Monet, who was still a major figure in art at the start of the twentieth century), and who wanted to do something new. The focus of Impressionism was on how things appeared in different stages of light. The focus for artists working in the deep shadow that such great work creates, was on including what we know about what is painted as much as what things looked like.

We know what an object would look like if we were sitting on the other side of it because we can walk around it. We know that things/people move. We know that we experience a space – say, in a bar – from a 360-degree perspective, not just from one viewpoint. Further, who is to say one viewpoint is better than another? We also know – and this is crucial to our understanding of this new world of painting – that we are painting these things on a flat surface. Painting becomes a 'self-conscious' act, so rather than having an ambition to 'fool the eye', it acknowledges its plasticity, it acknowledges that it is a reinterpretation of reality on a painted surface.

LEFT: **Second panel from** *Music – Diptych 2.*

This may seem to be a very dry and indulgent attitude, but the artists who were in at the beginning of what we call Cubism quickly recognized that you could have fun with the pictorial space in front of you. You could create puns around this concept of depiction, using well known and private signs to 'play' with your subject matter. Above all, these artists created a sense of freedom to their work, away from slavishly trying to reproduce how things looked, into an area that was more complicated and conceptually aware.

To illustrate this relook at pictorial space, I can re-render the drawing of one-point perspective (the railroad, see below) into

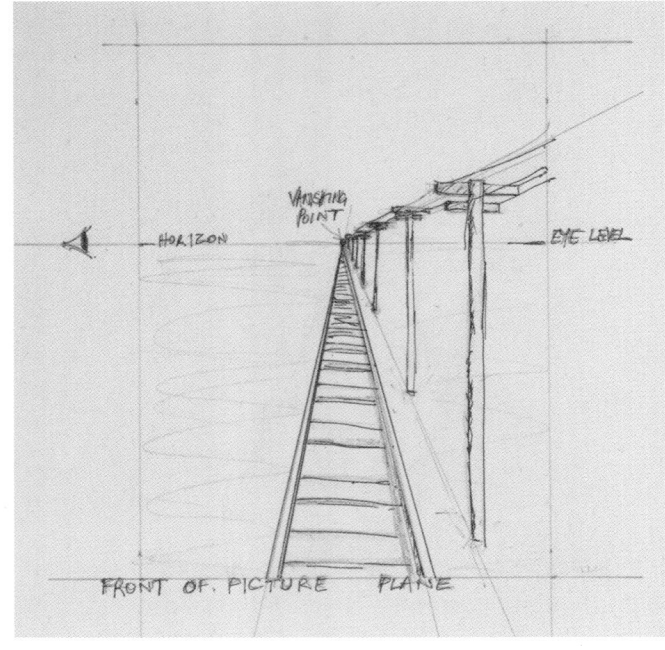

The railroad revisited.

DRAWING INTO ABSTRACTION

Cubist Railroad. In Cubism the bones of the composition are on the surface of the painting. In this way the painting becomes the pictorial event rather than simply describing a pictorial event. Compositional tricks and dynamics are described within the painting's appearance at a cost to 'realism', but these same dynamics can add to the ingenuity of the painting, if the demand for a 'fooling of the eye' is suspended.

a composition that appeals to more than simply the aesthetic (or otherwise) experience of a single space (see the main image). The Cubist movement was inspired to re-render their subject matter to include what they know about it, to be aware of the two-dimensional picture plane, not to fool the eye, but to engage it in a more complex relationship that could even include visual verbal puns and other hitherto excluded references from 'traditional' one-point painting.

This restructuring of the pictorial space inevitably opened another door to abstraction.

As art does not happen in seclusion from other art forms, it may be helpful to think at this point about a companion art form to Cubism – jazz. Jazz in its earlier forms took standard songs and then 'jazzed' them up by breaking down the original melodies and song structure to create a new form of the same song. Cubism does something similar in pictorial form.

In this chapter I want to have a look at how this initial opening up of pictorial space dominated twentieth-century painting and created an equally fast track towards abstraction, as with the release of colour from its traditional role. Sometimes this meant that the drawing within a painting followed the lead of colour. Sometimes drawing became simply a matter of an architectural structure for the work where colour became much more the focus of the subject matter.

To begin with I want to look at a seminal work of the cubist period in more detail. For this I have made a loose transcription of Marcel Duchamp's painting *Nude Descending a Staircase*. Please study the original when you can, because in this case I have emphasized certain aspects of the original to make it easier to understand those works that came after it, leading to greater levels of abstraction.

In the original, Duchamp is not just painting what he sees: he is painting what he knows about what he sees. And that's significant. What we have here are the first stages of abstraction, where what we know about something enters into the pictorial reality of painting it. The artist, in noting down all that he sees, is not depicting the (real) figure, he is representing the movement, and the fact that there is a starting point and an end point to this process. So in this sense, he is painting an event!

What cubist painting represents is a departure from naturalism, but in saying that, we have to understand that nature in the nineteenth century represented an idea of the oneness of all things pointing to God. So in other words, nature to a nineteenth-century artist was synonymous with truth, and this was synonymous with God. Truth and beauty were considered to be one thing. So this idea of God-ness and oneness suggested to artists that they were all painting aspects of one big idea.

This idea of truth or truths being relative, rather than absolute, appears to spring into our consciousness when we cross into the twentieth century. At the same time that cubists are fracturing hitherto sacrosanct rules of pictorial space, or jazz musicians are breaking with musical norms, in order to make creative work more in tune with the world that they lived in, Einstein was developing his more serious and complex theory of relativity to begin a break with Newtonian certainty in science.

Certainly at this time there seemed to have been a concerted break with an understanding of nature being an all-encompassing oneness into something which is more relative, and this notion of relativity – the relative stages of something – is something artists felt that abstraction could take on.

The work of the cubist painters visually acknowledged that the painting was simultaneously dealing with representations of the world, coupled with the fact that these representations were occurring on a flat surface. The idea of moving things around on the surface of the picture superseded the idea that the painting should 'fool the eye' and behave like a window through which we see the world. Cubists were acutely aware that this was a deception about a truth they knew as artists – they were painting things on a flat surface – so why not admit it?

I would suggest that this idea of relative truth is at the heart of Duchamp's painting, and it is this concept that was so difficult to digest by the established culture of the time. But at the same time it was just this quality that was so attractive to the *avant garde* in Paris in the first decade of the twentieth century. I have chosen this painting as a starting point for the break with the tradition of painting what is seen into 'something more complicated than that' because it so encapsulates this departure that Duchamp moved away from painting as the main vehicle for his ideas: he may have felt he had said it all in this picture, or that he felt that painting was a limited carrier of his ideas. But many others took the breakthrough of cubism as their starting point to explore more and more ideas of abstraction. These ideas could be generated by (almost) mathematical hard-line thinking, or from more lyrical and metaphorical standpoints. To look at the whole gamut of abstraction would take forever, but to get a hold of the variety of routes into abstraction I have limited discussion to works generated from the landscape, the body or the mind. The next chapter will make this clearer in visual form, more so than I can here within the limitations of (my) language.

DRAWING INTO ABSTRACTION

My transcription of *Nude Descending a Staircase*. Traditionally, processes of making the painting were hidden from view, rather like the back stage complexities necessary to create a theatre show are hidden from the audience. In this image it is more like they did away with the facade of the stage presentation and included the lighting rigs and props within the stage performance. In Cubism and Fauvism the pictorial tricks are made visible, inverted, and imaginatively played with to produce another kind of pictorial event. This sometimes heightened the emotional power of the work, sometimes (as in this image inspired by Duchamp's painting) had a more cooling, more intellectual effect.

DRAWING INTO ABSTRACTION

Cubist Seascape. In this work I have taken the same image as used in the *Fauvist Seascape* in Chapter 1 and rendered that in a cubist-type pictorial structure to make it possible to compare the different priorities of drawing and colour between the two styles. You can expand on these examples as a basis for your own compositions, hopefully developing visual clues or details to throw into the mix. Remember to always be playful in how you develop your ideas.

CHAPTER 3

LANDSCAPE, BODY AND MIND

It is understandable that artists, when feeling their way into abstraction, will relate their work to their experience of earlier art. Therefore we can often find in abstract painting a feeling of space that seems familiar to other kinds of pictorial space; sometimes these are deliberate metaphors for a place or an idea of the body. In order to find an inroad into understanding the impulse towards abstraction I have separated out three approaches to abstraction: landscape, body and mind. In the first two cases these follow on from the kind of representational paintings that precede them and make use of our expectations of pictorial space within each type of painting, sometimes to subvert them and sometimes as a way into the kind of space these painters wish to explore. In the final section we will look at those artists who have created work from a more conceptual approach.

As before, I have created studies alluding to differing approaches as exercises for you to try and make your own. Remember, we learn by making, so take these studies as starting points to make more studies of your own.

This was my original attempt to indicate how colour can disrupt the normal 'here to there' space of figurative painting as we can see in fauvist painting. Why not take an image – one of your own photographs of a landscape or townscape or suchlike will do – and try this for yourself? Play with the idea of disrupting the space with 'unco-operative' colour. See if you can set your teeth on edge.

LEFT: A Mondrian-inspired study.

■ LANDSCAPE, BODY AND MIND

In this painting I have redistributed the colours so the shapes have disintegrated into the surrounding colour. This has now created another kind of space. The painting has become even more 'tactile', and this touch is important to the look of the study. It will be good practice to play with the same colours and redistribute them over, say, a series of five studies in this manner. You will see that each study offers a different feel, dependent on which colour is dominant and how much 'incident' (that is, the shapes and forms in the original) is present.

LANDSCAPE, BODY AND MIND

By just changing the way I painted the surface, still using the same colours, the next study has changed the focus of the original. The painting (gestural) qualities are more to the fore, and other interests and pictorial incidents supersede traditional pictorial space. You can play with these elements in your own exercises, maybe reducing the colour tones to extremes.

■ LANDSCAPE, BODY AND MIND

By changing the tonality of the colours to an extreme we have lost all connection to the original painting and are off on another journey, much more to do with gesture and the prominence of the hand's journey through the paint. Don't worry about taking these exercises to this kind of extreme: the more of these you do, the more you will understand the roles of colour and gesture in your own work.

LANDSCAPE, BODY AND MIND

This painting started with a ladder shape (often seen in Miro's work), and spots of colour and shapes suspended in the space around it. Note that the absence of a horizon line increases the lightweight sense of the shapes floating within a deeper space. This absence of a sky/ground axis creates a world of complete freedom. Try making this kind of study your own, with different colour choices and shapes. Working on a series of such exercises can again add to your knowledge of colour and tone. For example, by changing the background colour you can change the mood of the painting, and using similar elements I can further examine specific colour relationships – the focus here is on a blue and red combination. It is also worth noting how the white shapes are active elements in the painting: this is the bonus of using a coloured ground.

Landscape

To begin I want to relook at the fauvist seascape (or you can, and should, use any of the alternatives you created).

In abstracted form, we can play with the colour and distribution of shapes and marks to recreate pictorial space. In these studies you will find that the way the marks are made becomes important to the new meaning and look of the work.

If we expand the idea of landscape to include the vastness of the night sky and 'other-worldly' spaces we can create a kind of space where shapes float in a non-gravitational way. Where the traditional (gravitational) pull that is found in horizon-type landscapes no longer exists, space is freed up so that your imagination can run riot. We get this feeling in abstract paintings from the surrealist movement by Joan Miro or Roberto Matta, or like shapes on another planet by Yves Tanguy.

The next study is obviously derived from Joan Miro's work. I am a huge admirer of his 'constellation series' of paintings and often use this kind of space as a starting point for my paintings. I have cheekily added the bird shapes from another important painting in this group – *Garden* by Paul Klee (1924). The idea of quoting other artists within your studies adds to the fun and play possibilities. This sense of play is important to abstraction.

If we make the shapes within this kind of painting space to be more geometric, then we have another strand of painting that utilizes this sense of vast space. This sense of space can be found in the work of Wassily Kandinski, an important figure in early abstract painting.

Internet search
Yves Tanguy; Joan Miro; Roberto Matta; Kandinski; Peter Lanyon; and more specifically a series of paintings entitled *Garden in Sochi* by Arshile Gorky.

■ LANDSCAPE, BODY AND MIND

In this study I have kept a lot of the kinds of incident as in the Miro-esque studies, except I have cleaned them up and put them into a more geometric language. I have scraped washes of colour across the shapes, and this has blurred the edges of some shapes. This has led to another kind or 'painterliness': it is much less gestural than the earlier landscape studies, but is still suggestive of movement, or at least it has changed the surface of the study without losing the sense of floating forms in a boundless space.

LANDSCAPE, BODY AND MIND

I have introduced more drama into this study by increasing the range of tonality of the colours; it is interesting to note that the 'feel' of the space has changed, and if anything has made the painting itself more dramatic. It is worth investing more time and energy into these studies, but please remember to be vigilant throughout these exercises – you are filling your storage tanks with knowledge accrued through making. This is a different class of knowledge than can be gleaned from just reading and not doing. You have to learn through feeling it as much as understanding it conceptually.

■ LANDSCAPE, BODY AND MIND

Body

There is a line of thought that all abstraction, and certainly those that fall in this tactile arena, is generated by our understanding of our bodies – our understanding of scale, or sense of balance, or proportion, how we measure: all our judgements within pictorial representation stem from the relationship of our bodies to the world. In this sense we interact with a lot of abstract art regarding our physical limitations.

As a first step in this section we can look at a more formal and

I have used the work of Ad Reinhardt as the basis of this study, though it must be noted here that in making this work, Reinhardt had admittedly looked at the work of Picasso and Juan Gris. It is a good practice when looking at artists whose work interests you to make a study of individual works. Making a transcription allows you greater knowledge of why they made certain decisions in the making of the original work. This study is making the point about a playful relationship to the body as seen through a cubist method, and by making further studies from this you can depart from the original or test the colour relationships in your work. In making this I changed the colour relationships of the original and altered some of the drawing to allow for another example of the primary colours in a composition (red, yellow and blue).

These torso paintings have ended up in a similar place to the landscape space paintings. Getting involved with the gesture and the more relaxed way the paint was added has resulted in similar results. This is not a negative thing: it obviously points me towards a way of painting that suits my personality. If anything, this manner of painting suits the body arena better than the landscape arena.

cubist-type deconstruction of the torso, and for this I have loosely transcribed an early Ad Reinhardt painting; you might continue this process towards further abstraction in your own work.

These ideas of a torso or body can be even more loosely restated, with the brush marks again reflecting the fleshiness of bodies and the skeins of paint as metaphors for the skin of the body. Again, see if you can take this further.

As we can see, this tactile response to the body can be further embellished through a more painterly approach, where the paint itself makes an association with the body. This in turn can affect the choice regarding the size of the painting – if we are to relate an abstract painting to a figure, we can emphasize this relationship by painting this in a figure-sized canvas. Looking at de Kooning's paintings we can get a feel of the body even though we are looking at skeins of paint.

■ LANDSCAPE, BODY AND MIND

In this study I have deliberately taken the body image to a very abstracted form. This kind of painterliness suggests the making process very clearly, and the gestures and the manner of its making are more bodily orientated than the imagery.

LANDSCAPE, BODY AND MIND

Ultimately an interest in the way the body makes a gesture in paint is readily seen in the web-like drips of a Jackson Pollock. Of course in his work the scale of his pictures is vast as compared to the limited size of these studies as exercises. But even on a small scale the whiplash of the drips is a gesture made with the wrist, and as such has its own dynamic.

In a lot of these studies and exercises I have used the brush marks and consequent painterliness to be more suggestive of body-type fluidity (think of Rubens' flesh). You can experiment with your own sense of colour and textural associations in your own work. And you can take things further...

In the next exercise I have used a section of the *Nude Descending a Staircase* transcription from Chapter 2. As an exercise, taking a part of another work and creating a painting out of a detail can be very profitable. It takes us further into a field of abstraction, where the lines and shapes are heavily reminiscent of bodily shapes but not distinctly so. In this area the painting becomes an abstract metaphor for, for example, skin stretched over bones or those areas of soft depressions. With this series of studies I hope to be able to show how profitable it is to work

■ LANDSCAPE, BODY AND MIND

By limiting the drawing in this painting to a section of a bigger work, the shapes have taken on another sense of movement and form. The painting looks more fluid, and the painting shapes become even more of a metaphor than a description of something. This collision of shapes could also lead us to look at a more biomorphic kind of painting that is suggestive of something but isn't actually.

This study takes the shapes of the previous study to more of an extreme. I turned the first upside down to create this next step, playing with each to see where it took me. The shapes in this study seem to jostle against each other right up close to the picture plane.

LANDSCAPE, BODY AND MIND

By playing with the balance of black and white another kind of painting emerges from the initial study. This is more fluid and gestural but with shapes filling the pictorial space. These are becoming more familiar to me, and reflect the use of shape in the paintings you will see later in the book.

In the final black and white study here, the white shapes have moved more into the foreground and created a tension with the black shapes over 'which is where' within the pictorial space. By limiting the colour (something I often do when exploring a new way of working) it is possible to look at the painting space in a different way.

LANDSCAPE, BODY AND MIND

The layering of the shapes and the colour separation suggest corpuscle movement and corruption or other microbiological metaphors. It may sound fanciful, but these kinds of images have influenced a number of artists once photographic evidence was published. It is an obvious abstract space that has many affiliations with abstract painting space.

from one work to another.

You can make your own versions of these studies using increasingly fluid paint, and even expand this on to canvas. As emphasized previously, all these exercises are an area for constructive play; besides, it is most enjoyable to push paint around in this way.

Internet search
Chaime Soutine; Willem De Kooning; Jackson Pollock; Robert Motherwell; Roger Hilton.

A lot of abstract artists have looked inwards into micro spaces as much as outwards to cosmological spaces, so in this last section I want to take a quick look at the possibilities of this kind of space, where biomorphic shapes or units of shapes can be utilized to create further examples of radical pictorial space.

Painterliness does not just have to be in the flow of liquid on a surface, it can also be in the use of brushes – bigger or smaller, they will affect the scale relationship in the picture space (see the 'theory of joints' later in the book). Through a judicious use of colour, a simple short brush mark made with a fully loaded brush can create a world in which a change of identity can alter the 'feeling' of the pictorial space, where darkness and light achieve qualities of space – soft, safe and familiar or arid, bitter or full to teeming.

So again, use these examples as just the tip of the iceberg of what you can do. Just play.

Internet search
Basil Beattie; Sam Francis; Frank Bowling; Gillian Ayers; Mark Francis.

LANDSCAPE, BODY AND MIND

Here we have a painterly (non-specific) ground and a centralized group of brush marks. It connotes a number of things in the world we can relate to – a peculiar flower or strange curly head, or grubs of insects. There are many things you can relate this kind of painting to; often artists have referred to micro-biological imagery to inform their paintings using this kind of approach. Once artists moved away from the standard depiction set-ups – still life, landscape, figure paintings – they found a new freedom of expression where their choice of colour and methodology allows them to relate to the world in a completely different way – in a way that focuses on the 'feeling' of the work and less on its correctness of depiction.

■ LANDSCAPE, BODY AND MIND

The Mind

Now that we have looked at the fleshy body metaphorical abstractions, and the space-rich, landscape-orientated paintings and studies, let's look at a more 'hard-nosed' approach to the structure of paintings.

To begin this section I think it would be advisable to mention that one of the dangers of abstraction, and one that is often detected in artworks produced by beginners, is that, if we are not careful, decisions we make in our work are wholly taste derived. By this I mean that our taste in colour and composition determines our decisions about what goes where. The dominance of our taste supports our understanding of these elements at the time of painting, but always carries the danger of producing derivative work. The reason is simple: if we are to make a work that conforms to our current or historical understanding of what looks good, we are condemning the picture to represent what is known, and is predictable. In fact, this kind of work simply reinforces our prejudices about composition and colour relationships. We have to turn this around and make work that challenges our prejudices and complacencies. In other words, we make work in which we learn something new through the making of it.

This impetus not to rest on the laurels of our collective taste is what drives art-making into new areas of discovery, and can often result in work that takes a while to get to know and like. It is also why artists who were extremely famous in their day fade to relative obscurity in historical terms. Those who reflect the taste of the day can often be highly celebrated – and this works for other, even more temporal areas of our culture (step forwards popular music) – yet after a few years we wonder what all the fuss was about.

The idea of challenging the taste or received aesthetics of our inherited art objects (or music, or dress sense, or whatever) and well-used methods of art-making is fortunately something that from adolescence we are used to doing – and this is another reason that artists are disparaged by the dominant culture of the time. They are seen as troublemakers to the standing order of the day – and they are, but we would not progress as a culture without this in-built process of renewal.

So in order not to fall at this hurdle, artists utilize all sorts of means to make decisions that are beyond 'mere' taste judgements. It must be said that it would be impossible to make art without making taste judgements, but these should be treated very suspiciously.

For the first of these exercises and studies we can call on the precedent of Hans Arp, who as one of the initiators of the Dada movement – see note below – often used chance to create his compositions. In this his determination was to avoid what he regarded as judgements of bourgeois taste ruling his work: in other words, he tried to surprise himself in what could, or could not, be useful to make his work. He would hold pieces of pre-coloured paper above a sheet of paper and drop them so that as they fell the arrangement would be realized into a challenging (or otherwise) composition. The idea of non-arrangement or accidental arrangement (relative) was to challenge notions of perfection and the ideal.

You can 'play' with this method, maybe creating shapes that are different to the basic ones you see here. Arp moved on to using what was termed biomorphic shapes in his later work.

Collage Arranged by the Rule of Chance. In this work I simply let the torn pieces of red paper fall onto the surface and pasted them down where they fell. In this work I am trying to illustrate Hans Arp's Dada-ist method of making work. By allowing chance to create the composition the artist avoids making direct aesthetic decisions within the declared pictorial space. Dada was a 'protest' art movement and as such was directly opposed to cultural and intellectual conformity. Works such as these led directly to Surrealism and their use of techniques such as 'automatic writing'.

- Dada is often termed an anti-art movement, but was in fact a highly questioning movement about the then current cultural and moral norms within the European culture of the time; they saw themselves as anti-bourgeois, and challenged the norms of their time. The influence of Dada bounces through the twentieth century and into our own.

LANDSCAPE, BODY AND MIND

In my interpretation of a Mondrian I have used the 'golden section' to create rectangles within the composition: this creates the centre section, as can be seen by the (giveaway) arcs used in their making. I have then used the yellow, red and blue rectangles to balance the work.

In this study I have used tints of the primaries along with full-blooded colours to achieve a compositional balance.

Artists such as Piet Mondrian would look to historical notions of the ideal to inform their choices – for example, the golden rectangle (see the next chapter) – and relocate them in their own challenging compositions. Mondrian would often utilize primary colours, as these were a 'given' and not tastefully arrived at through mixing colour (such as a mixed tone or secondary/tertiary colour), which could in this purist arena be seen as a compromise.

Mondrian's works were determinedly related to his philosophy of theosophy, and he decided his new art-making process was to be called neoplasticism. Its idea was to ignore the particulars of appearance and find its expression in 'the abstraction of form and colour, that is to say, in the straight line and the clearly defined primary colour'.

The proponents of the theosophical movement believed that it was possible to attain a more profound knowledge of nature than that provided by the appearance of things, and much of Mondrian's work was inspired by his search for that spiritual knowledge. In doing so he obviously investigated the claims made for the golden rectangle and phi – as the eternal balance of beauty.

As we can see from this, abstraction was not interested in making things easy, far from it: it was a means to try to understand something much deeper than the 'merely' empirical. Of course, this does not preclude the rest of us getting involved with a bit of play with Mondrian's structural approach to abstraction. So please take time to look at the way you can make this approach your own.

All sorts of artists were influenced and attracted by this hard-edged 'constructed' approach to abstraction.

Internet search
Piet Mondrian; Kasimir Malevitch; El Lissitzki; Hans Hoffman.

■ LANDSCAPE, BODY AND MIND

These images offer you further structures to 'play' with: as you can see here, as soon as you use a coloured ground, rather than an all-pervasive white ground, the relationships change to a less 'hard and fast' relationship – what in the art world would be called a 'hard-edged' relationship in the pictorial space – to a softer and less specific kind of pictorial space. The first looks constructed with all the implications that that suggests, and the other more like a composition. In truth artists are more comfortable with certain approaches, and this is definitely linked to their personalities. You will find that your personality leads you to be more interested in a hard-edged or soft-edged, or romantic or classical approach. You will find out more about yourself as you proceed.

LANDSCAPE, BODY AND MIND

CHAPTER 4

SYSTEMS, GRIDS, FIBONACCI AND PHI

I would like to look here at other means of avoiding the predictable and tasteful within abstract painting. Cubism, as we have seen, takes us from simply representing what we can see to also include what we know about what we can see. This change in attitude and purpose immediately opened up abstraction to focus on the conceptual aspects of art-making. (It could be argued that no method of making art is entirely conceptual, nor entirely tactile.) Every artist has to find their place in the space between these poles or methods of making art. You will find this is where your own personality will dictate your bias in this sliding scale. Please listen to this, because the method you use to make art should always be in sympathy with your personality (the way you do everything), otherwise it will be an uphill battle to make anything whilst you fight your own inner demons.

Most artists have a 'system' of making work – I would call this their methodology – but sometimes artists will utilize a logical or mathematical system in order to present their work. We will look here at three systems that have been frequently used: grids, Fibonacci and phi.

Grids

A grid is a basic ordering system that has been used very frequently over the last hundred or so years. Artists have returned to it a lot. It could be said that cubist pictorial structure is the application of one or two grids on top of the subject matter in order to create the fractured surfaces we see in this work. But usually if one is used it does not appear to have been applied mathematically or regularly except in extreme or mannered circumstances.

A kind of grid often appears in Paul Klee's work, where landscapes can be re-determined in a grid-like form. The colour in each square of these paintings seems to be a visual equivalent to the feeling of the whole or the details within. This is often what I will call soft-focused grids – not ruled lines and rigid structures, but a structure compromised with the subject matter within it. Despite their rigid formation, these paintings can be evocative of space and light.

In fact the concept of a grid offers up a rigid possibility that is even more compromised by the way the materials (and their tactile possibilities) are used. Because of the seeming order presented by a grid, if a more painterly approach is used, the resulting picture seems even more so. Where the methods do not conform easily to the maths, the artist concentrates even more on the richness of the surface, or the light, or the colour used in the painting.

Students at art college are often introduced to a grid form in their early years of study, usually to disturb and provoke their sense of what is, and is not, a picture space, and to get rid of pictorial preconceptions so they can concentrate on what other elements of their work are doing – colour and tone in particular.

The use of collage in a grid form offers up a lot of pictorial possibilities.

Even a grid of minimal colour choices can focus on the colour qualities that make up the seemingly black square, as we can

LEFT: Study after Paul Klee.

■ SYSTEMS, GRIDS, FIBONACCI AND PHI

To make this I used an old art school trick of cutting up two different magazine adverts and interspersing them (according to Hans Arp's use of chance), creating lots of incident within a regular type of structure. Very often this is followed up with a painted version approximating the incident with one colour to produce a grid-like study, as in the following example (although this grid was not derived from this collage).

This study is reminiscent of the soft-focused grids mentioned in Paul Klee's work. It is simply made so that where the brush marks are visible and the hard edges softened through the approach to the painting of it, this study gives off a hand-made 'folksie' sense of abstraction, more atmospheric and less hard-nosed.

Abstract artists have made extensive use of a simple (or sometimes more complex) grid. In my example I have simply collaged rectangles of colour on to a coloured ground. With a grid structure you can use all of the space in a painting with the grid, as we have seen in the exercises above, or make the grid within a pictorial/colour space, as here. Just 'playing' with these two alternatives – the rectangles of colour and the colour(s) of the ground – will allow many valuable exercises in relating colours to each other. See how each rectangle has what I call a pictorial 'weight', some lighter than others, yet others denser and heavier.

54

SYSTEMS, GRIDS, FIBONACCI AND PHI

Another collage in grid form, but this time cut-up squares of studies that have been overlaid with colour in order to take them towards a black. Interestingly enough, where this has not happened – through the paint running out or not covering an area – the study has a sort of pictorial incident that allows a sense of light and dark even within this minimal representation.

I painted this study by mixing tones of colours with black, to try and get as near to pure black as I could but to still have a remnant of the original colour left. I have used reds and greens (in full blown colour: very difficult bedfellows) to create this study through this basic grid form.

SYSTEMS, GRIDS, FIBONACCI AND PHI

A great many abstract painters want you to experience their work physically as well as conceptually.

see in a collaged grid...

... or in this 'black' painting made out of the darkest tones of colours.

We cannot paint this 'dark-toned' exercise without reference to Ad Reinhardt. Reinhardt was on a quest to rid his paintings of all the unnecessary 'frippery' of individual composition, quirks of brush marks, and the contemporary understanding of expressionism. He was searching for a Zen-like purity to his work that was not concerned with the material or illustrative. For him, his art embodied one idea (but this was a big idea). He defined his artwork in terms of what it did not do – his sharp wit and humour were brought to devastating effect in his comments (usually by inference) on his contemporary artists in Europe and the USA, and their then obsession with the material reality of paint (such as Jackson Pollock, de Kooning, Franz Kline and Pierre Soulages).

Reinhardt was looking to derive a black painting from colour, by ridding it of light, so the painting seems to suck in light as you acclimatize to its abrupt minimalism (a black square). Eventually you can perceive the colour in the work enmeshed in this sense of a non-reflective absorbent surface. However, he did have a specific size he worked on, and this was referenced to human scale – he made his paintings on squares, the size as far as he could reach (around 5ft or 1.5m), so when hung it was experienced as a physical object.

A lot of paintings are to be experienced in this way, where you unconsciously 'measure' the painting relative to your own body. You will find a number of abstract paintings are larger than the easel paintings we have become used to in the work of the Impressionists, Fauvists and Cubists.

Of course we do not have to be overly concentrating on taking colour to black: we can look at colour moving through the tints to white. The grid can be used as a structural constant so that you can manipulate (or test) loads of colours and their various tints and tones. It is a fantastic tool to get used to colour combinations and intensities. The only way to find out more about your colour is to play with this structure and test it to its limits!

Of course grids can also appear as the background to other shapes – see the images later in this chapter – or they could be less geometric and formalized.

The more recent understanding of pixels, and the digital construction of images through this kind of photography, have meant that the grid has been utilized to create a space between photographed images and abstraction. The use of a grid has become so varied, and such a fertile ground for artists, that we could write had a whole book on this structure of abstract painting alone – so please research the artists listed below and add your own favourites.

Internet search
Ad Reinhardt; Sean Scully; Trevor Sutton; Bridget Riley; Stephen Buckley; Mark Francis; Terry Frost.

SYSTEMS, GRIDS, FIBONACCI AND PHI

In this exercise I took the colour tonality to very close relationships in the lighter end of the spectrum. By photo-shopping a black and white version this becomes a white painting with very little tonal difference between the pinks and greens. It would be a good exercise to take this further and see if you can make a painting that has distinct coloured areas ending up with the same tone, so that when it is converted to black and white it is one tone. Try it and see.

■ SYSTEMS, GRIDS, FIBONACCI AND PHI

I have used our old friend the geometric circles (from former exercises) and combined them with an irregular soft (painterly) grid, and then a more regular ruled grid structure. Of course being me, I could not help but scrape a layer of medium over it to make them more pictorially interesting. My temperament is definitely more in the Paul Klee end of the use of grids.

SYSTEMS, GRIDS, FIBONACCI AND PHI

This study is influenced by my tutor from university, Terry Frost. Terry was a noted UK colourist and at the time I was studying with him he was attempting to 'take on' the idea of black as a colour in a series of paintings. His regular shape (half circle) was derived from (that is, abstracted down from) seeing boats bobbing in a harbour in St Ives. In this study I am trying to obtain a series of black colours through colour mixes collaged on to a blue-black ground. No matter how 'formal' the organization of his paintings, Terry Frost never rids his work of a jaunty quirkiness, reflecting his personality without taking away from his work – he could never be po-faced.

Before we leave this grid section I must include the use of a circular version. Artists have used a circular grid form to function in a similar way to the rectangular grid, in that it gives a sense of non bias – neither a landscape-shaped rectangle nor a portrait-shaped rectangle – to the composition. For this reason it can be difficult to work to.

For examples of earlier exponents of the circular grid form we could look at the work of Robert and Sonia Delauney. They structured many of their paintings and drawings with obviously hand-made circular forms, and this allowed them a liberated and joyous use of primary and secondary colours. I have made two studies loosely taken from these paintings of the early part of the last century as something you can 'play' with yourselves. They may seem very familiar to you, as these drawings and paintings have found their way on to a huge number of surfaces and fabric designs, and in that sense they have been very influential.

The use of coloured circles has also been the staple of art college students' early work, in that you can use the circle in much the same way as the grid, as a given structure through which you can try any number of colour and tonal ideas.

Internet search
Jasper Johns; Kenneth Noland; Carol Robertson; Joseph Albers.

The Golden Section

Other mathematical proportions and sequences have also been used a lot over the last sixty years or so by abstract artists (not to mention musicians and architects). The first that we will look at is variously called the 'golden ratio', golden section, or the divine proportion (in Renaissance times), and is a mathematical proportion that goes back so far I cannot calculate it. It is the basis of the proportion in ancient buildings such as the Acrop-

■ SYSTEMS, GRIDS, FIBONACCI AND PHI

The bold shapes seem to need bold colour decisions in order for the studies to glow with colour. The second study fractures the circular form as a humorous nod to a cubist-like drawing structure. This is another form where you can be liberated to try all sorts of different versions, testing your colour knowledge even further.

SYSTEMS, GRIDS, FIBONACCI AND PHI

With the use of a compass we can create concentric circles. This is a compositional device within which we can look seriously at how colours relate and how we can learn from the variables. It was a standard technique in late twentieth-century painting to use the same structure so you can 'test' the variables – in our case colour, and the experience of colour. This concentric structure means that you can follow it or create special dissonances/harmonies with it dependent of the values of your colours. Joseph Albers made a series of concentric squares of colours on a square canvas and used this structure to look at thousands of colour possibilities.

SYSTEMS, GRIDS, FIBONACCI AND PHI

olis, and is the basis for any number of compositions of Renaissance paintings (such as Leonardo's *Last Supper*). It is also the basis of any number of natural phenomena, including the proportions of the human body. It is often used in representing the human body, and you would learn a lot about the golden ratio in life-drawing classes. In terms of it helping in the composition of a painting's drawing structures, the instances are too multifarious to go into here, as what we are after are those instances in abstract art.

The golden section (or golden ratio, or phi, or the divine proportion) was used extensively in exploring proportion within the compositions of Renaissance art. It was known to the Greeks and was rediscovered as a guiding principle in art in the Renaissance, and has been used extensively in paintings ever since. It is best explained by likening a line to a piece of string. You can cut this string at various points along its length, and the two pieces would have a mathematical ratio to each other. But there is only one point along this line where the ratio of the smaller piece to the larger piece is exactly the same as the ratio of the larger piece to the whole. This point is called the golden ratio, or phi. For those who are mathematically inclined this ratio is 1:1.61803339887... or more manageably 1:1.618.

One of the features of the golden ratio is that when constructed in two-dimensional form in terms of a square and a rectangle created from that square, these can be added to, or drawn into, in such a way that when an arc is drawn through the structure it creates a perfect spiral.

In my example here, each rectangle is created by finding the mid-point of the first (largest) square and, using a compass, inscribing an arc from its top right corner to the bottom line; where this crosses the base line, a rectangle is drawn. The relationship (ratio) of the smaller rectangle to the square is the same as the ratio of the square to the whole. This smaller rectangle can then contain the second smallest square/rectangle ratio and so on. This allows me to inscribe an arc across the space of each square, and so a spiral can be drawn.

SYSTEMS, GRIDS, FIBONACCI AND PHI

In this study I have used the golden ratio to help organize the coloured squares into a harmonious composition. The intensity of the colours can be varied and thus carry different pictorial weight. This is yet another exercise where, by creating your own variants, you will learn more about how colours can carry intensity or pictorial weight, which can upset the balance of a composition or reassert a balance and harmony.

The point of all this is that the golden ratio can be used as a structural tool, as we have seen in the study after Mondrian. You will also find this ratio in any number of geometric abstract paintings – in future try seeing if you can find them when you look at reproductions in art books.

Internet search
Look up the work of Piet Mondrian, Ben Nicholson, Dorothea Rockburn.

Fibonacci

Having looked at the golden ratio, the next most popular sequence structure in a lot of art made in the twentieth century is what is called the 'Fibonacci sequence'. Fibonacci was reputed to have been a certain Leonardo of Pisa, and the first instance of this sequence is reputedly in a book dated 1202. As it relates specifically to the golden ratio it has a history of appearing in the structure of many works of art. It became very popular with minimal artists of the 1960s and 1970s such as Donald Judd and Sol Le Witt.

This is a very simple sequence to create: beginning with 0, we add 1, then add the sum of the two numbers which gives us 1, then 1+1 gives us 2, then 1+2 = 3, then 2+3 = 5, then 3+5 = 8 and so on. In each step of the sequence we add the last two numbers to get the next.

Of course you can play to your heart's content with this – I know this will not appeal to all of you, but it will certainly suit

As an example of utilizing the Fibonacci sequence in structural form I have used an integrated use of the sequence using solids and spaces. As you work across the 'depicted' object the solid sequence utilizes the (1) 1, 2, 3, 5 and the spaces do the opposite 5, 3, 2, 1 (1). (The first and last (1)s are sneakily represented by the space either side of the object.)

I have used watercolour here so that the mixed colours consist of one colour overlaid on to another; the transparency of the watery medium allows for this basic form of glazing.

SYSTEMS, GRIDS, FIBONACCI AND PHI

This painting suggests a larger size: artists often utilized a large scale for such paintings, as this gave the colour even more prominence and allowed the visual aspect of the painting full throttle. It makes the painting more exciting to experience.

65

■ SYSTEMS, GRIDS, FIBONACCI AND PHI

some personalities, and will help with decisions about how you can structure your work.

As a means of using this sequence to structure abstract paintings I have linked a very basic use of it to structure the following exercises in primary (red, yellow, blue) colours, overlaying them to get the secondary colours (orange, green, and violet), and then overlaying these to get the various tones of tertiary (basically shades of brown) colours.

This first example begins with blue at each end of the rectangle, then the other two primaries are put next to each; these are mixed to get the secondary colours, and these to get the central tertiary colour. As you can see, these vertical strips of colour follow the early steps of the Fibonacci sequence up and down – 1, 1, 2, 3, 2, 1, 1.

Just to explain something about layered colour, the second exercise starts off with a different prime colour, this time yellow – note the different quality of the tertiary with the yellow underneath the red and blue.

The third one is a different shape, and starts off with red. Again the tertiary colour has a different look due to the way the colours are layered.

Other Systems

A more physical layering of colour that also produces interesting tertiary colours is to layer the colour using thicker paint, scraping it over the surface with a squeegee or similar implement. These paintings are part of a series of works that have a simple system derived from the colours used – yellow, then blue, then red; blue, then red, then yellow; red, then yellow, then blue; and each colour has then been applied in each layer – bottom, middle and top.

So in this painting the three panels have a different primary as a top coat.

This physical means of painting adds another dimension to how the painting is experienced, and we will come to this arena affecting the way a painting looks in the next chapter.

Internet search
Barnett Newman; John Mitchell; Jules Olitski; Morris Louis, Veil paintings.

For this study I made three squeegeed layers of the primary colours within a thick medium. This introduced a more tactile feeling to the final work. I remember using this exact system and method to make one of my student paintings, inspired by the title of a Barnett Newman painting *Who's Afraid of Red Yellow Blue*. So I used a single coat of red, yellow and blue in different sequences.

SYSTEMS, GRIDS, FIBONACCI AND PHI

The richness of the colour in this study is made tactile through the use of thicker paint, and the lack of discernible brush marks means that the scale of the work is indeterminable through the usual mark-making autograph. This painting could be human size or minute.

CHAPTER 5

PAINT AS STUFF

In this chapter I want to move on to an area crucial to my own way of painting, and I will use examples of my own work to look at this more closely. It is important to know what colour offers us as abstract painters, but it is just as important to understand how the paint we use – paint as stuff – affects colour and what we paint, especially in relation to how expressive, cool, gestural, tactile or intense we want our work to be. I also want to touch on the way I paint, what I paint with, and how my colour is applied. This also affects the reception of the finished work, and all of this is summed up in one word, each of these components making up our painting 'methodology'.

Coloured paint offers us three pictorial dynamics: tone, intensity and space. These pictorial properties are further compromised or intensified by the qualities of the paint we are using. I will try to explain these effects using my own paintings.

Hue/Tone/Tint

Firstly I should define what I mean by hue, tone and tint. 'Hue' means the nature of the pure colour – so although blue would be the name of a colour's hue, how a cerulean blue is different from an ultramarine blue is also an aspect of that colour's hue. This is often derived from its source material, the mineral or vegetable products that are the source of each colour. It is possible to get the same tone of different types of colour by mixing, but you will lose the intensity of the hue. So a lot of artists use differing types of colour as a tone within their work, to maintain the intensity of the colour. Keeping to the theme of blue, cerulean blue is lighter, ultramarine blue nearer to a mid tone, and Prussian blue near to black.

A quick visit to your art shop and you will see that colours come in lots of different natural tones or types. Thus alizarin crimson is dark, rose madder light, viridian green is dark, sap green is light.

In Renaissance times the cost of colour varied. As an example, lapis lazuli was ground up to make the iconic blue we often find in Renaissance paintings (our approximation would be French ultramarine blue): you can recognize this specific blue in Renaissance painting as it is almost always the colour of the Madonna's robes. Lapis lazuli was an exceedingly expensive pigment in Italy at this time, more expensive than gold according to some sources. So whenever a painting was commissioned, the contract would often stipulate how many figures were to be painted in this colour, and this stipulation often acted like a status symbol on the part of the commissioner. What was so desirable about this blue was its hue.

Now most painters at this time would be painting this expensive colour in all its natural tone and beauty. But where necessary, to balance up a composition or render an object in light, and certainly utilized more freely with other colours, it would be necessary to moderate the intensity of the hue to alter its lightness or darkness, so that it could be positioned into the composition and internal dynamics of the painting (its pictorial structure). This would be achieved by using a tone or tint of the natural hue of the colour, by adding white (creating a tint), or black (creating a tone) to the natural hue of the colour con-

LEFT: *Blue Pieta*.

cerned. So natural (straight from the pot) colour can be moderated through the use of a tint or tone, which of course are achieved through mixing.

Tones and tints of colours sacrifice intensity (of hue) in order to compose a pictorial 'event'. That is, in order to create a space or to add dynamics to it, lighter and darker colours need to be employed.

With the invention of the oil tube, artists' materials became much more portable. Prior to this invention most artists ground their own colour or bought it from a colour merchant in bladders. With the invention of the tube, artists were able to conveniently take their canvases out into the countryside and paint *en plein air* (a French expression which means what it suggests – in the open air).

It is no surprise, therefore, that when artists were confronted with the vivid colours of nature, they became more and more obsessed with purity of colour and moved away from tonal/tinted use of colour to a more vibrant and intense use – straight from the tubes. In order to maximize on this vibrancy the custom of utilizing a pure white ground became more common. (Titian/Rubens/Rembrandt, for example, would paint on coloured or toned grounds.) The white under-painting maximized the light coming through and around the sides of the colour, thereby increasing its vibrancy.

Colour was now used more strategically – a careful use of complimentary colour was a daring and vibrant use of colour in this 'new' painting as exemplified by Degas, Monet, Sisley and the other artists associated with Impressionism. This fascination with the use of pure colour was amplified by Van Gogh, Gauguin, and other artists associated with the Post-Impressionist movement right up to Matisse and the Fauvists.

It is worth noting here that the tonality of the colours was important to this use of colour. It was no good painting complimentary colours at full blast – they just cancelled each other out, but if a darker orange tone is applied in and around, say, a full-blown blue colour, the effect is much more harmonious.

Internet search
For further study see *Portrait of Madame Matisse* by Henri Matisse (1913) – note the use of orange (her scarf) in this painting, which brings the blues and greens alive.

Space

In Chapter 1 we looked at how 'colour space' is confounded through the juxtaposition of intense and tonal colour to emphasize or undermine the pictorial expectation set up by the initial drawing. Where colours are used to contrast with the structure set up by the drawing – what I will call the 'here to there' aspect of the pictorial space – a kind of pictorial tension is created. This effect of colour space cannot be underestimated as one of the tools in any painter's toolbox.

In Chapter 3 we looked at the ways in which different attitudes to the drawing of the space can cause differing resolutions to abstract pictorial composition. How paintings are structured can affect the liberation or containment of colour to maximize its effectiveness and expressive power.

There is a limit as to how the final area of consideration can be achieved in small-scale exercises. We now need to move to full-blown painting, in my case on a scale that is relative to my body size, where in the painting I can extend my arms to encapsulate that scale of gesture if necessary. In this instance, when the painting size ensures a physical presence, then the consistency of the paint affects its physical presence to compete with the large scale of the canvas. In this way when we look at these types of painting we look at them aware of our own body and its limitations.

Paint as Stuff

So now that we have established the creative tension that can be found in manipulating colour intensity and hue, it is time to look at the material that carries this colour. You will find that the 'stuff' of paint – its physical properties – its glossiness, its opacity, its thickness (impasto) and its see-throughness (transparency) – can be manipulated to create another kind of creative tension within your pictorial space. If we think of paint as a carrier of the colour (in technical terms the 'medium'), we can then see how varying the properties of the paint can affect the quality of the pictorial space in your paintings.

The different uses of the 'stuff-ness' of paint will either free up or compromise the colour space in your paintings. By trying to utilize these properties you can explore the dynamics of colour further. The beauty of paint as a medium is that it allows an almost infinite variety of possibilities. The only limitation to these is our imagination and daring – which in turn, I would guess, are products of our personalities.

For the media I work with, please refer to the tinted section 'Media, Tools and Techniques' [below] where I outline them, and say why I use them. But remember here, the purpose of all media is to carry the colour you want to use; you can get into the science and craft of this, or simply use a ready-to-go paint medium. It all depends on how much you want to be involved with it.

My original reason for experimenting with differing media was quite simply down to one thing: how to cover as much of the surface of the painting without sacrificing the quality of colour I was after. In other words, how do I make (expensive)

MEDIA, TOOLS AND TECHNIQUES

MEDIA
The medium you use in your work will also affect the look of it, and the choice of medium is also a very personal concern. I have used acrylic paint in the past and been very happy with the results. Once I started to use larger quantities of it I purchased the ingredients: the polymer, the pigment and the additives (to make it denser or opaque, or thicker) in order to have a greater degree of control over the medium carrying my ideas.

Now, however, I use oil paint on my canvases for one reason: when I look at thick oil paint I see the colour first and the material second, but when I look at thick acrylic I see the material first and the colour second. For me, on the scale I paint in on my canvases, I am happier with the purer colour 'vibe' I get from oil paint.

OIL PAINT
Oil paint is where pigment (ground colour into a fine powder) is 'suspended' or thoroughly mixed into an oil medium; this is often linseed oil, but you may also see oil paint mixed with poppy or safflower oil. Most commercially available oil paint is more often the product of pigment being ground into a linseed oil medium.

I use oil paint as my preferred medium on canvas. On paper I will use anything that can differentiate shapes and areas of colour from each other – inks, watercolours, gouache, acrylics, anything that will do the job. In canvas painting I find the medium that best suits me is oil paint with the additions of various oils, varnishes and beeswax.

I must restate here that when you make a painting, it is important to use a medium and a method that suits your personality. This may seem a strange thing to say, but you will have to account, in your methodology, for drying time and mixing time to create a 'flow' in your work. Without this flow in your use of tools and materials, you will not have any 'flow' in your thinking.

So, I use oil paint, but I use it in conjunction with two other main types of medium: cold wax and stand oil.

COLD WAX
Beeswax is a natural preservative and works wonderfully well with oil paint to create what are often called 'encaustic' paintings. You can see the products of this kind of painting in the magnificent 'Fayum' portraits painted on ancient Egyptian caskets (there are some excellent examples in the British Museum). These date back to the first century AD but are still vibrant with colour. They are a fantastic advert for the longevity of colour in encaustic painting, due to the preservative nature of beeswax. But they also advertise the carrying properties of the medium – it allows the colour to shine.

I tend to use a lot of oil paint so I buy it in large tubes. I keep a lot in stock as nothing is worse than running out of a colour in the middle of a painting.

PAINT AS STUFF

'Cold wax' is a form of painting similar to encaustic but with less of the bother and toxin-related dangers of inhaling hot wax and oil paint (as encaustic is always applied hot and often reheated). With cold wax you create a medium where beeswax is suspended in turpentine and the resultant mix is cooled into a paste that remains workable for a time, but when spread more thinly it also has drying properties that hasten the drying time of the oil paint. Thus allowing for the technique of layering of colour, in other words, it can offer a cruder, yet quicker, form of glazing.

PREPARING COLD WAX MIXTURE

You will need a pair of pans, one pan or container to float inside a larger pan. Sometimes an emptied and cleaned catering can may be used inside the larger pan. You will also need a quantity of beeswax, pure turpentine and a wooden spoon.

In a clear space in your studio you will need to set up a heat source (in this case a single electric ring heater). Place on this a large pan of water and bring to the boil. Once this is achieved, set the heater to a low setting (a simmer setting in cookery).

Pour a quantity of beeswax pellets into a separate and smaller container. We will be working on a third of pellets to two-thirds pure turpentine for this mix, but you will get your own preference for a recipe through trial and error, using this as a first guess.

Place this container into the larger pan and simmer on a heat until the pellets are melted and you have a clear liquid form to the beeswax. Once this has been achieved, take the smaller pan from the larger one and the heat source and whilst still hot, pour the pure turpentine into the liquid beeswax; set aside to cool. I stir the mixture just after I pour in the turpentine to make sure the mix is thorough. Once cooled you will then have a paste that you can add to your oil paints. As I mentioned in the text, this will allow you to spread your colour further.

As you can see, these pans have seen some action.

PAINT AS STUFF

Please take every care to do this process safely:

- Under no circumstances should you ever melt wax by direct heat – it has a low flashpoint and will burst into flames using this kind of heat if you do not use this double pan method

- Similarly do not pour your turpentine into the hot wax while it is still on the heat, for exactly the same safety reasons. Take the hot wax away from the heat and place on a sturdy surface to add the turpentine.

STAND OIL

Stand oil is a much thicker form of linseed oil and does almost the opposite of the wax: it makes the oil paint thicker and more 'oily', and without a drying agent slows the drying of the oil paint considerably.

You will want to take your hot wax further away from the heat than in this example to add the turpentine – it's a mock-up!

■ PAINT AS STUFF

I use lots of types of brushes but I bought these in just these two sizes; the rounded shape means I can get clean edges, without the draggling hairs you can get with square-edged brushes. But in the end you get best control with the best equipment.

Remember, a varied use of any medium that can carry paint can achieve differing effects, and this makes the painting come alive in a way that simply painting one way all the time will not allow.

TOOLS

As previously stated, I use brushes of all kinds as long as they can carry the paint.

A new, fairly good decorator's brush is also quite acceptable, in my view.

The next tool I use – a lot – is my scraper…

PAINTING TECHNIQUE

I thought that it would help if I were photographed painting a picture. As is usually the case in these things, the photographs are not entirely 'real', but I hope this will give you an approximation of some of the methods I use in my paintings.

You will already have noted that I go about the paintings in non-traditional manner: I paint ground colours over the top shapes, I blur the paint around, and skate thinner wax colours over oil-rich shapes. I have said before and will say again, I am not a purist. Please remember, paintings are meant to be experienced 'in the flesh'. The experience of looking is important. Paintings that seem dull in photographs can sing in reality, and vice versa. So you must promise yourself that you will look and look again at the

I always sketch in the shapes and structure of the painting with charcoal – larger sticks suit me better.

Because this painting is over more than one panel, where the panels are next to each other I paint over the join and then pull them apart. It is important to be flexible so these panels may be turned around and pushed and pulled around as I work with the paintings – there are no rules about this.

As the painting develops it can be worked from different angles.

art you can see around you. More importantly you must take any problems you are experiencing in the studio to those major art works available to you in the great museums. If, for instance, you have a problem situating a blue in a painting, go to your local museum and look at the way all the artists in there have used blue. I always tell students that once they study art they cease to be entertained by it – for them, looking at art is part of their work. They must take the issues they are trying to deal with to artworks around them. Everything must be analysed to make the most of your own work. Of course, it is better if you do this in a spirit of play…

Once the shapes are in place I can scrape over the first of a series of wax-rich veils of paint with my trusty scraper. The wax paint skims over the oil-rich shapes and often picks up colour from them that adds to the action of the scraper. This process unifies the disparate aspects of the painting (the differing base colours) and engages the whole surface. From this point the painting is done on the wall.

This paint can be quite viscous and physical. I am not worried about painting over shapes – they can always be re-stated.

PAINT AS STUFF

The wax-enriched paint dries overnight and allows the re-statement of shapes and other detail to be put in. Another veil of white seems to have gone on top before the shapes changed between these photographs to resolve the central area of the painting.

Finalizing details with loaded brushes: as you can see, the shapes have changed colour – the original ground colours still pop through, but the basic structure did not change. This is due to the extensive studies and drawing preparation, as can be seen in Chapter 11.

oil paint go further? But the benefits of experimenting with the carrying medium also attracted me because it enabled me to utilize differing thicknesses of paint (impasto). The control of the thickness of the medium is important to any kind of painting as it brings a further dynamic to what possibilities are on offer.

Remember, a varied use of any medium that can carry paint, can achieve differing effects, and this makes the painting come alive in a way that simply painting one way all the time will not allow.

Types of Painting Method

This is not an exhaustive account of all possible methods: here I am amplifying those methods I have used in specific paintings, illustrating the benefits or otherwise of these methods.

Wet in Wet

In the nineteenth century, along with the advances of oil-tube technology, artists began utilizing a more immediate form of painting. This did away with time-expensive techniques such as glazing and under-painting, and introduced the world to a technique that simply moved paint across the surface – one that was quicker and more easily able to 'capture' the effects of light on nature. What in academic painting of the nineteenth century was only used as under-painting became used as a medium (much criticized as 'amateur' by the consolidated academic painters of the time) that focused on the immediacy of effects and painting technique. This is termed 'wet in wet' painting, where the whole surface of the painting is kept 'alive' and wet as successive hours of work are occasioned.

Some artists would go to extraordinary lengths to keep the paint wet: Willem de Kooning experimented with differing oils and other media to achieve an even more mobile and dynamic surface to his work. It is even rumoured that he used mayonnaise in an attempt to triumph alchemically over the impossible potential of mixing oil with water – though restorers, it must be said, cast grave doubts over this heroic myth. His purpose was to make his own work feel as though his hand had just left the canvas.

Internet search
Monet; Picasso; de Kooning.

Impasto

Impasto means to lay on the paint thickly. Often artists have used their palette knives to lay on the paint so that the physical stuff of the paint is very visible and inflected. Nicolas de Stael is a classic example of this approach to painting, and was an artist who took landscape towards abstraction – or rather, he interpreted landscape and made it into a pictorial experience, not only referencing the landscape but using it as a jumping-off point towards a rich, visual experience of the painting itself. Laying on paint in this way – which is often a great experience of the 'stuff-like' qualities of oil paint – can often reduce the painting into a kind of slab-like mannerism. So take care with this method, especially when the particulars of the application are adhered to at all costs. This can often be at the expense of what other pictorial adventures the painting can hold. It is always important to maintain an open mind whenever you are developing your painting methodology.

Internet search
Nicolas de Stael.

Opaque/Transparent

To contrast two uses of paint qualities – in this case opaque and transparent – I will look at two works made around the same time and derived from the same kinds of source.

In the first painting, *Untitled Blue* from 1998, the surface of the painting is opaque. The method I use means that the shapes are not simply on one level – they appear to be more or less submerged away from the surface of the painting within the white top layer, which has been scraped or squeegeed over the shapes. A few shapes are restated above the white to create a more dynamic sense of pictorial space, with a distinct sense of movement. The making of the painting has dictated the mood and content of this abstracted, or more aptly described as distilled reaction to the source material.

The drawing for this painting was derived from a myriad of studies I made of Michelangelo's Pietas – this one from the *Pieta* found in the Academia in Florence (which uses a particularly white type of Carrara marble). Although this was the starting point of the work, I was prepared to go with the flow of the experience in its making (I call that 'listening' to the painting – in any case a visual equivalent of listening) to achieve an experience that became distant from the look of the *Pieta* but intimately connected to it metaphorically in my own internal narrative. It reminds me of marks in the snow and in front of this painting – around human height and scale – the gestures reflecting my scale and creating a sort of sculpted space analogous to, but not directly depicting the original marble sculpture.

Untitled Blue. The blue shapes are made by turning a fully laden brush (around 2 or 3in wide, so a lot bigger than easel painting brushes) of blue on to a ground colour – I think this was a darkened grey colour. Then a white opaque paint, thickened with the cold wax, a little linseed oil and some turpentine (to get the right mixture) was applied using my French decorator's scraper – used like a squeegee in effect, but more manageable in how it can turn and cut through the paint. As you can see, some of the blue shapes are all but painted out, others survived the skin of paint more readily, some were blurred by the process, and some of the blue was spread into the white. This process was redone – the blue shapes applied and the surface scraped over them – until I was satisfied with the result. I remember in this instance I reapplied a few blue shapes again as the last action of the painting. This allowed the blue shapes to exist on several levels within the matrix of the painting. I was reading Dante's Inferno at the time and was interested in the sense of a frozen, ice-bound reading of the central shapes and how this related to the way Michelangelo's sculptures seemed to escape from the block as he worked (as can be witnessed in what we call the 'prisoners' or 'slave' sculptures in the Accademia Gallery in Florence).

■ PAINT AS STUFF

Blue Pieta. This painting was more inspired by the beautifully finished *Pieta* of Michelangelo's in St Peter's Church in Rome. This is a very much earlier *Pieta* by Michelangelo, and as such displays an astounding range of techniques, including a polish to the finished marble. It was this polish that I wanted to explore in this painting – translating the polished surface into the transparent depth of the finished canvas. In this painting the depth is greater and has a sense of the shapes being suspended in a liquid, with just a few floating to the surface. The idea of the surface of the painting also being the background of the shapes allows a fluidity of spatial position within the painting. The liquid-like surface is also emphasized by the drips and dribbles on the surface of the painting, and increases the sense of depth of the darker and gloomier shapes glimpsed within.

In this first painting the paint was more opaque and the values of colour interaction were around marks on a surface, while in *Blue Pieta*, also from 1998, transparent glazes of blue were overlaid on the impasto shapes whilst they were still wet. The nature of the paint transforms the space within the painting into another series of analogous spaces – the more liquid-like it is, with the depth that that would suggest, so the shapes within the painting look as if they are swimming around in the space (like microbes on a petri dish, or amphibians in a pond). The dribbles of white paint look like light glistening in the pictorial space. This painting is larger than *Untitled Blue*, allowing more space to well around you when looking at and into it.

By comparing these two paintings we can see that although I am using similar colours, the results are very different in terms of pictorial space and feel. One is opaque and snow/ice-like, the other transparent and water/sea-like. In the first, white has a dominant role, in the second blue has a stronger presence. The changes to the 'form' of the paintings, how the paint is carried in the medium, have a significant effect on how the painting 'feels'. We can see the contrast of an opaque medium with that of a transparent and glazing medium.

Internet search
Michelangelo's *Pieta* in the Church of St Peter in Rome, Michelangelo's *Palestrina Pieta* in the Accademia in Florence.

Gloss and Matt Surfaces

My paintings, just as in the examples above, can be split into two groups: ones where the paint is delivered principally with a matt surface, and one where the paint is delivered with a more gloss surface.

The surface of your paintings is very important, as it can draw you into the pictorial space or hold you off so you do not penetrate to any pictorial depth, but stay on the surface. The quality of the surface really affects the reception of the painting and alters the impact of the colour. Glossy opaque surfaces come at you, they are bolder and brasher, while matt surfaces are more reticent and reserved. Interestingly enough, glossy depth – as in *Blue Pieta* – is more luxuriant, whereas matt glazes tend to sit more on the surface of the picture. The added value that transparency gives to colour relationships can make them more dynamic and complex.

All these qualities are something you can play with and discover, provided you adhere to my main rule in the studio: let the hare run, but always be vigilant. With the use of colour in abstract painting you have to be exceedingly vigilant to catch effects and pictorial qualities that will enrich your ideas, giving birth to yet more pictorial ideas to play with, and so on. The hard work done with the exercises in this book will increase your vigilance to recognizing something worth using or keeping in the painting process; consider the work put into such exercises and studies as like putting fuel in the tank for use later.

Experiment and play with these elements and you will not only find your own style, but will enrich the experience your audience will have when they look at your work. It will make that experience more complex and dynamic. You will find that even these poles of formal conventions – gloss/matt, thick/thin, opaque/transparent – can be mixed, abused or compromised, to pictorial effect and intensity.

Spread of the Pictorial Space

One of the difficulties I experienced when I was introduced to making large-scale abstract painting, and one of the most difficult things to achieve, is an idea of (a consistent) 'spread' of the pictorial space. It is so easy for the painting to 'collapse in' on itself when you are working on large sizes, and painters can often find that they lose any kind of tension across the picture surface.

In my example, *Urban Narrative A* (1999), the painting is 6 x 10ft (183 x 305cm), and the question of how to maintain the tension across the surface is crucial to its success. As you can see, the major shapes in the painting seem to enter or exist at the edges. I say 'enter' in this instance, as the drawing (or design) of the painting was derived from my study of the history of the 'Annunciation' in religious painting. This often used image – throughout art history every painter who has ever attempted to depict the Christian narrative must have made at least one attempt at depicting this story – featured strongly in my own studies of religious painting and sculpture.

The Annunciation is the story of the Angel Gabriel coming to Mary and announcing that she would conceive and bear Jesus, and he was to be the Son of God. These works interested me on many formal levels; I learned that the church had decreed that there were three 'official' reactions of Mary to this announcement: the first was one of surprise, a very human reaction to the visitation of an angel to tell her the story. The second was one of grief, as she is told the whole story of Jesus, and grieves at the knowledge of what is to come. The third was one of transcendence, where Mary as the future mother of the son of God has the wisdom and spiritual strength to transcend this knowledge in her understanding of its purpose.

The creative development of each of the three gestures is a major purpose behind these traditional artworks. I began (mentally) collecting 'Annunciations' whenever I was looking at Italian painting during a number of visits and stays in Florence, cities in surrounding Tuscany, and Rome, to collect these ges-

■ PAINT AS STUFF

Urban Narrative A. In this painting the shapes were created through the application of a Prussian blue to black colour applied by my biggest brush (around 5in, or 12cm). It was important to get the scale of the imperial shape to be consistent and big. These were painted a number of times until I was satisfied. The shape on the left curls backs into the painting space, and I equate that with the often-curved shape of the Madonna in Italian Annunciation paintings. As you can see, this shape was adjusted and changed colour during the painting process (both shapes started off red), and these changes create a sort of narrative fabric to the end product, so I don't mind them being there. The left shape went steadily towards the edge of the painting during this process of painting it, and then overlaying (scraping) a thin coat of paint across the surface. The space between the edges of the shapes and the edges of the painting are where the paint has run off the main shapes and been deposited in that space, so we can see the Prussian blue running over the yellow. A fortunate side effect of this was the feeling that the shape on the right-hand side was entering the painting space leaving behind a trail, as you would see in cartoons, like the Roadrunner. This was good for me because it gave this large shape a sense of entry into the picture and also suggested movement in the left-hand shape.

tures of pictorial significance in my mind's eye. Often Mary is depicted in the movement of turning as if shocked to see this visitor, and this informed the painting of the left-hand side shape in this painting. So I wanted this shape to appear in reaction to the introduction of the shape to the right. I wanted the right-hand side shape to appear more magisterial and forceful, as it 'arrives' from the right-hand side of the painting.

The layers of paint across the surface create a sort of impacted and dense surface, with a thinner, more fluid and gestural paint on the very surface of the painting space. The yellow colour allows for this use of surface without it receding in a traditional landscape effect, as a green or blue set of tones would be more likely to suggest. I also thought this almost 'non-natural' spatial sense of colour that the yellow represents came from my sense of colour in my urban environment and not at all rural in its effect (hence the title). It also nods to the use of a worn or eroded gold ground, as found in the older Byzantine paintings that I have seen on my travels (reasons are never just one thing).

The point of this painting is to spread the tension across the surface of this very large pictorial space, so that the painting is consumed in a visceral way, with almost a sense of touch. In this sense the painting points to one of my major concerns: where the physical making leads to a metaphysical response – how, when you encounter the work, you subconsciously relate it to your own body – your height, your reach. The 'spread' in this sense is important to the meanings within the painting, and this sense of spread affects, and is affected by, the colours in it.

The second painting featured in this area of concern is one of a series (see below) of works done for an exhibition called 'Fictional Spaces' in 2003. It is called *In Relation To* from around that time. In this work, what would have been two distinct forms have merged within a web of 'tendrils' connecting one side of the painting to the other. The brush marks making up what you could call the 'image' of the darker forms spread across the 5 x 6ft (152 x 182cm) surface of the painting.

In the next painting, *Narrative – for RS,* we can see another means of stretching the paint and colour across a large picture surface. The under-painting of the green in the latter is again compromised by the white paint scraped across the surface, so

PAINT AS STUFF

In Relation To. The darker forms are created in near-black colours with my large-sized brush. These shapes were arrived at through a series of smaller paintings, and some etchings that suggested to me two 'figures' tied to each other, which takes them further along a line of thought initiated by *Urban Narrative A*. The near-black colours were mostly a green-black, but made through a mixture with blues and reds, so as it thins out you can see it moves to purple or green. This green contrasts both tonally and in terms of its complimentary colour with the pink of the surface/ground. The way I apply the colour over the shapes creates a confusion over what is ground and what is surface, and what its relationship is to the 'image'. So the various veils of colour applied with a squeegee-like effect with my trusty scraper sometimes swell over the shapes. In this instance the shapes were accentuated or supported with colours applied to their curves, and as you can see from clues left in, the shapes started off life as a yellow shape – possibly as a reverse of the last painting where the ground was yellow and the shapes blue/black. In any case my paintings usually form themselves in the making process and often surprise me – I do prefer it that way, as I find out new things in my painting process rather than concentrating on what I already know, and project that.

Narrative – for RS. Again the shapes are painted on with larger brushes 'cushioned' by a white and a black shape in this painting; then the green, then whiter veils of paint are applied using the scraper. I realized that by applying the scraped colour to the canvas (before spreading) by painting it on in regular strips from top to bottom, when it was spread across the surface, by happy chance it revealed the under-colour, in this case definitely a green. The scraper also, through directed chance, created a grid effect on each passage when spreading the colour across the painting. The drips that you can see then are negative drips – that is, the colour that the drips were hiding until scraped over. This ghosted painterliness was something that really intrigued me, and you will see this phenomenon used in other paintings. It creates yet another visual opposition to the richer, obviously brushed on, glossy orange shape colour. So positive and negative are yet another duality I am playing with here.

that it is uncertain where each lies in relation to the other. Are the green stripes on top of or behind the white? In fact the 'image' created by the orange form is also within this matrix rather than simply lying on top, so this confounds the layering process even more. The 'ground' in this case maintains the sense of tension across the picture surface, and this web is something the orange shapes are grappling with.

These two paintings also offer examples of working in series (*see* Chapter 6) in that the drawn shapes can be varied within a series, but also meditations on certain colours can be similarly considered in greater depth. In these instances the role of the green colours related the reds and the orange side of the spectrum.

CHAPTER 6

WORKING IN SERIES: THE PIETAS

Artists have often approached a certain subject matter in a series of paintings, using this as a device to vary formal aspects of their work based around the same kind of image or drawing structure. Think of Monet's series of paintings of water lilies or haystacks, or Picasso's series of paintings based on Manet's *Dejeuner sur l'Herbe*, where the drawing colour and structure are all 'played with' to see what he can come up with. The idea of working in a series of related works allows the artist to establish a formal constant (an image or a drawing structure) so that other aspects of the picture can be improvised upon (often colour relationships). We have looked at this again and again in the exercises in the earlier chapters. Through a thorough grounding in such exercises, and an equally thorough understanding of the forms and drawing structure within a series, you will have the confidence and ability to improvise in the act of painting. This is hugely important.

The use of a series has meant we have witnessed a huge amount of invention and experimentation with colour – from Mondrian's grids, through Rothko's clouds of colour, to Gerhardt Richter's squeegee works. I am no exception to this rule. Working with a series of works around a basic theme allows all sorts of invention and improvisation that will feed into future work. It will also facilitate extreme decisions concerning colour or form, allowing the artist to indulge himself a bit. I highlighted earlier the need for vigilance in the studio, and this approach allows for what I call 'vigilant play'.

I am illustrating this aspect of my work with a series of images of paintings I made on and off for at least fifteen years based on Michelangelo's *Pieta* sculptures. In these paintings we can see shapes and forms in motion and play based (very loosely) on the great man's sculptures. The first two of my paintings featured in Chapter 5 in this book were investigations into this subject, and I have made many drawings around it, taking increased liberties with the forms (playing with them) so that I could find my entrance into my paintings.

Michelangelo made four distinct and very different works around the subject of the 'deposition' or pieta in his lifetime. Two are located in Florence: one is in the Academia, called the *Palastrina Pieta* (now believed to have been completed by someone else), and the second is in the Museo dell'Opera del Duomo (the Museum of the Cathedral), called the *Deposition of Christ* (which was reputedly made for his own tomb).

The first pieta made was the *Pieta* in St Peter's Basilica in Rome, created in Michelangelo's earlier years and fully demonstrative of his powers as a sculptor of marble. The final pieta, called the *Rondanini Pieta*, is in Milan and is by far the strangest looking (and most unfinished) of the four.

Now there is a lot of information and misinformation surrounding Michelangelo's last three pietas, especially as they appeared to be unfinished. It was undoubtedly true that in the latter stages of his life Michelangelo was drawn to this subject matter in terms of his own mortality. However, regardless of the reasoning behind their making, the formal aspects of these four works, and the spirit within each, formed in my mind a series of

LEFT: *Pieta XI*.

WORKING IN SERIES: THE PIETAS

The first image here is a first attempt to improvise around the structure and image quality of Michelangelo's *Pieta* in the Florence Academy. It is a very white piece of marble so I kept the tone lighter. The purpose of this painting, and the studies I was making at this time, was to find forms within the sculpture that I can improvise on in later works.

works that both profoundly affected me when I was in front of each, and allowed me access through an incessant referral to them in drawings and paintings; through these I managed to manipulate the 'found' image of the pieta into a series of works that explore a whole host of painterly possibilities as suggested by and through the originals.

My first attempt at painting this was a small work, tentative and light in colour and nature. I did not want this to be a deliberate transcription, I wanted it to be abstracted from the original to give me space to move as an artist responding to these fantastic and major works.

I followed this with a vast series of drawings, some always playful and to some eyes irreverent. I include some studies here, as they may give a flavour to the deconstruction and reconstruction of a composition that has always fascinated me.

I seem often to be inspired by sculpture in my work, especially marble, where there is no relational colour involved. I can then let my own work utilize the forms to express my own abstracted spirit in my work, to clarify to me what I was after. In other words, there was space for me to work in an abstract series of forms related to the original, but free of it.

This is only one series of works I made rethinking images from Roman Catholic image sources. No doubt this intensity of interest was a feature of my thinking around a time of family bereavements, and a whole personal history relating to my mother's Catholicism (I am not), something I have truthfully not really admitted to until now – but it does seem obvious. Nevertheless 'reasons are not just one thing, they are many things', and this is a reminder to be healthily sceptical about what artists say their work is about: they may think it is about one thing, usually something topographical (for example, the formal relations within a work) but when you live with a work like a painting, the reasons it gets to be the way it is run fairly deep.

So for whatever reasons, I was very interested in these sculptures of Michelangelo, and they appeared in a number of works I was making, and continued to do so for a good many years.

My Pieta Series

The first of the few chosen larger (6 x 5ft, or 182 x 152cm) examples of my painted work around this theme is called *Pieta – Grief*. The shapes within it are like bleached bones of the composition with the colour surface washed across the white shapes, and the tone and atmosphere of this work have a darker quality, which leads to the title. There are dark shapes that slowly emerge out of the ground.

The second painting in this series *Pieta XI*, reverses the tonality somewhat, and I became interested in how the white and the Prussian blue interrelate in a coloured ground. The sweeps of the yellow across the blue create the green to blue tones. A lot of the gestures and detail within the composition are improvised, and I place a lot of emphasis on improvisation; and as I have emphasized in the exercises and studies earlier in this book, working in series allows for improvisation to surface in the painting process because the drawing becomes a kind of constant, although I can improvise around this as well because I know the family of forms so well.

The third painting, *Pieta XII*, utilizes a different coloured ground, nearer to the orange/red spectrum and where the blue becomes less dark and more intense in its hue. The interplay with the red becomes the formal relationship at the centre of the painting. The nature of each of these paintings varies one from the other: part of the joy of working in series is that it allows a 'compare and contrast' aspect to the group. Incidents in one sometimes carry over to another, but come out as another visual alternative. Thus the top shape in each is a play on the old method of picturing a halo as fire coming out of the head. In each of these paintings the topmost shape has an action

WORKING IN SERIES: THE PIETAS

As you can see, these are not reverential transcriptions but a sort of visual 'riffing' when thinking and looking at the original. The aim is always to find something new to me within my pictorial space, that will be of use to me when I make a painting.

WORKING IN SERIES: THE PIETAS

Pieta – Grief. The second image here is a detail of the painting showing the surface and the way the physical act of painting affects the 'look' of the painting. These paintings are unreservedly physical, and the viewer is meant to understand them as tactile objects as much as an image. In fact it is the integration of the tactile elements with the iconographic aspects of the painting that is important. To quote Gulley Jimson, the fictional painter in Joyce Carey's book, *The Horse's Mouth*, 'You feel the painting but you use your eyes to do it'.

Pieta XI. This painting is slightly smaller – 5 x 4ft, or 152 x 122cm – and the main shapes are Prussian blue with a yellow veil of paint over the red ground. I like the way the white accents work in this painting, and the very fluid space that is generated.

around it of vertical or horizontal strips of paint, which are meant to play on that idea. This is an example of the 'studio narrative' exerting a formal influence on the finished painting: I really do see these as signs for heads, and I really do see a sign for a ribcage in each.

The fourth painting has more discrete (separate) and flatter forms, and the space has an otherworldly, watery, 'phantom zone' feel to it. The shapes are very different and discrete from each other, the white surrounding the blue shapes and keeping them from joining up to make anthropomorphic shapes.

I hope these four paintings reveal how one basic drawing structure can fuel a variety of approaches. I wanted the colour to work in a sort of non-natural way, choosing bold colours to begin with, and letting the process of making create the secondary and tertiary tones.

Each painting follows the process we should now be familiar with, where a brushed-on shape or series of shapes is then overlaid with a veil of colour, and then this process repeated until I 'find' the painting within the process. Then I shore this up by repainting certain areas to bring them to the surface so there is a pictorial tension within and across the painting. It was through this work, developed further in other paintings, that I determined a face-like abstract shape – or should I put it, a shape that plays with the concept of being a face (in this case, two eyes and a mouth)? The idea of finding something that fits my internal (studio) narrative and works within the painting as a kind of visual pun, was something I felt had a 'fit' in my work. Following the blue paintings already discussed, the final image here, *Pieta XIII,* was one of my all-time favourite paintings. It came about, as a lot of my work seems to, through a kind of des-

WORKING IN SERIES: THE PIETAS

Pieta XII. As I hope you can see, this painting has a drier feel to it compared to its predecessor; it has more of an opaque surface, and in this one the orange was re-stated in a 'troublesome' area in the centre of the painting. This has given a different feel to the glazed areas where the blue has passed over the orange.

Pieta XIII. This was the last painting in this series and the shapes are cooler and more stylized (within my lexicon of shapes). It feels distinctly the coolest of the four paintings. The veils of colour have pushed the background away from the blue shapes, and these have been highlighted by a white surround, sometimes re-stated but mostly under the final thin veil of paint. (It must be said a lot of my paint ends up on the floor!)

peration to find something in these shapes and forms, and to find something in this process. In this painting I found an interaction between what could be termed 'image' and what could be termed 'ground' so they became mutually dependent and non hierarchical to the importance of the painting: the surface and the background were indistinguishable, in fact they are one thing and the 'images' are embedded in there. It gave me pause to think about it. I knew it was better than the work made hitherto, and I liked it more (once I got over the initial difficulty of recognizing what was there).

I liked the reverse tonality of the marble into black and the ground/surface being the purer white, that white not exactly being the ground as it is obviously laid over the red under-painting. So it worked for me both formally and emotionally – and as a genuine piece of work.

Pieta after Michelangelo.

CHAPTER 7

GESTURE AND THE THEORY OF JOINTS

Mark-making is undoubtedly a very human record of the passing of the artist's hand. In large-scale painting the mark-making can affect the sense of scale of the work, from intense small-scale marks to grand sweeps of paint across the entire surface. I have a 'theory of joints' which I think relates to the scale of a painting regardless of size. If the joints used in the painting process are the second joints (from the tips) of the forefinger and thumb, the product is of a gesture of very small scale, often found in pencil drawing and very figurative painting, for example Johannes Vermeer or Jean-Auguste-Dominique Ingres. Of course, it is in the interest of these painters that gesture is kept to a minimum or cancelled out in the painting process so that the viewer is focused on the image and not the making process. In abstract painting such gestures need to be consistently repeated to create an intensity across a larger-sized canvas. If this happens – as, for example, in a lot of Patrick Heron's later paintings – the paintings have less of a 'sweep' across the surface of the work, so that movement within the work is minimized to manipulate the viewer to focus on the intensity of the colour within it.

The second set of joints to consider are the wrists. If the wrist creates the gesture, then the canvas will need to be larger to accommodate it, and the sweep of this gesture will create a looser effect. In figurative terms we are in Franz Hals, and Manet/Monet territory. The difference between the depiction of the face of Rembrandt's *Hendrickje Bathing* – the finger/thumb joints – and the sweep of the way the chemise is realized (wrist) illustrates this difference. In abstract terms this looser approach is often prefigured in expressionist paintings, where the intensity and (limited) sweep of the paint suggest as much about the 'passion' of the maker as the image in front of us. The colour in these paintings becomes part of this focus, so the painting carries a gesture of intensity within it; these are never calm paintings, and the colour used reflects this in the dynamic, rather than harmonious relationships we find within them.

Internet search
Hendrickje Bathing by Rembrandt van Rijn; for fabulous gestural painting look at the work of Chaim Soutine and Willem De Kooning.

The American painters of the mid-twentieth century take us further in terms of the scale of gesture, so we start to see works that utilize the elbow as a gesture, until we see the shoulder as the joint best used to make paintings of grand scale and size. Philip Guston would be making works where the wrist action and elbow-pivoted gesture were controlled to produce beautifully coloured and very particular abstract paintings. In their early publication his works were grouped under the term 'abstract impressionism', to give you an idea of the harmonic

LEFT: The action of scraping the veil of lighter paint across the surface began in the centre of this canvas. I simply loaded a large (5in or 12.7cm) brush with white paint and painted this down the centre of the painting, covering what was a yellow veil of colour in two fully loaded stripes of paint. I then scraped or squeegeed this paint to each side edge of the painting. As this crossed the wet and richly painted red shapes it mixed with and blurred the far edges of the shapes. This seems to have intensified the experience of the red in this painting, with the yellow, white and pinks supporting these intense shapes and colours.

GESTURE AND THE THEORY OF JOINTS

complexity of these works.

De Kooning, on the other hand, was always given to a more dynamic gesture – I would say he uses wrist, elbow and (sometimes, but rarely) shoulder-pivoted gestures to make his work. De Kooning's earlier work was often urban in appearance (the violence of the city) rather than pastoral in effect, although his later work becomes increasingly pastoral when he relocated from New York City to East Hampton.

Jackson Pollock released an even grander gesture, where the shoulder pivot is crucial in creating his webs of colour using dripped paint.

Internet search
Compare Philip Guston's *The Return* (at the Tate) to Willem de Kooning's *Excavation* and Jackson Pollock's *Autumn Rhythm.*

The theory of joints is another fun thing to consider when looking at abstract paintings – how would these marks have been made? Like all attempts at making 'rules' about painting, obviously there are exceptions, and artists have a nasty habit of confounding theories. So they are only as good as long as they can help you describe to yourself the effect of your work, or the effects you try to engineer. In other words, none of this is a pure science. But your vigilance should not remain in the studio, and looking at art as purposeful play – in the same way as the approach I recommended to the exercises in earlier chapters – is as important as making it.

As a postscript to 'gesture' in painting, I must remark on the way that fluid paint often creates drips in my work. I have always considered these to serve a purpose in my painting. Drips often emphasize the gesture, in a sense of 'collateral damage' to the way you made the mark. They also serve another purpose, in giving a sense of immediacy to the finished painting.

But they can also indicate the order of the layering process, what goes on when. I found I could play with this, because when I put a loaded brush of paint on the canvas before I squeegee it across, it often dribbles downwards. If I then scrape this paint over the surface it leaves a thin deposit across the base colour, except where it was painted on initially. Here there is a drip-shaped expanse of the under-colour, which acts like an illustration of a drip as it has no substance – like a shadow of wet paint rather than the evidence of it – acting like a negative to the positive shapes. This can confound the apparent narrative of the making of the painting, and act as another kind of visual pun around the tactile nature of the surface of my work.

Sometimes I have used a larger squeegee-type implement to scrape the ground-colour paint across the more deliberately painted shapes. This imparts an even larger gesture to the work, and the shapes in the work appear almost in a storm of paint, with a forceful sweep across the painting. This can contribute to a sense that the shapes are perceived as under the surface, as if under water.

This painting, *Narrative – Charon II* (2000), came from many of the studies I made from Michelangelo's *Last Judgement* – in this case the demon Charon (who can be seen at the bottom right as you look at the vast fresco) whipping the souls into hell with the oar from the boat he uses to transport the damned to Hades. I put the yellow into this painting to heighten the intensity of blues, and this in fact turns out to be in mutual support of each colour: the blue dominates and the small intense yellow shapes are even more intense because of the surrounding colour space they inhabit.

GESTURE AND THE THEORY OF JOINTS

The gesture across the surface can be even more regulated to a simple action from left to right or right to left, as can be seen in the painting *Intimacy* (2001).

It must be said of all the paintings in this chapter that the build-up of surfaces and under-colour to the top coat as described was never really premeditated and planned: the final image of the painting is 'found' in the making process. The under-painting is usually the sum of a series of lost guesses as to how the painting should be finished. Each layer of paint is an attempt to finish the painting. Wrong guesses are as valuable as good ones, as they provide the meat of the finished work. The way I work is still in touch with the concept of action painting, and has a performative aspect – or rather, the marks by their residue demonstrate that an action has happened.

In *Pretty Things* (2001), there is a gesture to each of the shapes in that each has a wristy or sometimes a shoulder pivot gesture to its making. However, the surface also has a gesture through the scraper making its presence felt. In this painting the scraper is a larger implement and is scraped across the surface fairly rigidly in a horizontal action. This process creates another sense of scale in its non-anatomically associative mark-making, which is larger than the series of pivots described in the theory of joints (above). The surface of the painting is covered in what appears to be drips and dribbles of orange paint. These are in fact the 'shadows' of where thin blue paint has been scraped across the top of the initial orange under-painting, as in the manner explained in *Narrative for RS*. These indications act like evidence of action, but the interrelation and confusion around what is where (the pictorial logic) in its turn creates another pictorial tension within the work. The colour in this painting is basically set up as a complementary colour painting – the colour and tonal relationships of the blues within it complement those of the oranges, each heightening the effects of the other. So the confusion of what is where and how, is intended to add to this interplay.

CHAPTER 8

TRANSCRIPTION AND ABSTRACTION

A word or two about the use of past art in current painting: I could never guess at limitations in art making, so anything is always possible within the physical limits of your work. This includes past works of art that move you, or lodge in your mind as you go about looking and learning from it. In trying to figure out what it is about a picture or sculpture, we naturally draw it or work with elements taken from it. We learn by making. This has become an unending source of inspiration and learning in my own work, so much so that I continually return to certain motifs and re-use these forms as simple formal exercises, or with a deeper and more significant connection to the narrative.

The next two paintings are more traditionally transcriptions of original paintings, and I include them here as they are significant steps in the creation of my own system of abstract signifiers for figurative images.

I was involved in a series of exhibitions around 2008 that was conceived to see what happens when artists reconfigure actual paintings in collections. The first was in Northampton Museum and Art Gallery and the painting concerned was *The Virgin and Child with St Stephen and St Lawrence* by Girolamoda da Santa Croce.

The second of these paintings involved a transcription or reinterpretation of Jan Gossaert's *Hercules and Deianira* at the Barber Institute in Birmingham. The work I came up with was called *Intertwined Formality I*, from 2007; this was painted slightly earlier than the Northampton painting, but exhibited later.

Now that I had become involved with this aspect of transcription I decided to make a third and final work more directly focused on an art object. I wanted this to be more ambitious and to allow me more freedom than the other two works allowed, although these works did throw up a lot of pictorial incident that progressed my understanding of colour and structure within the kind of space I had developed in my paintings at this time.

Altarpiece

The next example is a painting that in its purest form consists of five panels: each panel represents a pictorial entity in itself, while collectively the five are meant to involve the viewer in a complex series of relationships. The panels are based on the structure found in the Swansea Altarpiece: this magnificent work of art can be found in the Victoria and Albert Museum in London.

This altarpiece is one of the few remaining artworks that remind us of what would have been the basis of a potentially flourishing visual culture in England if the dissolution of the

LEFT: In this painting, *There's Light and then there's Light* (2008), I 'abstracted' the heads of the two saints and the Madonna figures. One of the saints on either side of the Madonna and child had tight curly hair, and I found I could 'represent' this through the use of a series of brush marks in Venetian red. Also the face became the three line shapes in white, and this allowed me an entry into this (admittedly loose) transcription and to tie this painting into the series of works I had developed to this date. This is where the concepts of an abstract sign for 'head' became more realized. I have used this sign in any number of paintings since.

TRANSCRIPTION AND ABSTRACTION

Intertwined Formality – 1. I interpreted this painting using three bits: the two figures and Hercules' club. The two figures of the title were posed in the original with entwined legs and arms across each other. I interpreted this utilizing two colours with writhing shapes crossing over and intermingling slightly, the lighter colour stemming from the differing tones of the skin types in the original, with the club as a third colour element. The blues and pinks are reinforcing the colours of what were once figures (with a pun around blue for the boy and pink for the girl).

You can see that across the five panels of *Altarpiece in Five Panels,* the tonality changes, although the colour relationships set up a chain of links leading from one to the other where I am attempting to offer differing roles of each colour in terms of the 'ground' or incident within and across each of the panels. The tonality spreads from light to dark, and the luminosity and intensity of the use of colour vary relative to each panel. This link across the space between the panels is a feature of multi-panelled paintings, and is something that intrigues me intensely. You can also see that the process of scraping over rich brush marks of colour carries on, but varies considerably from painting to painting: the balance of this activity next to the solidity of the brushed shapes allows for a differing emphasis in each panel as you pass across the whole painting. It becomes more and more apparent that I am starting to think less of gestural and painterly effects within each panel, and a more considered image making has taken its place. This approach is expanded upon in the next series of paintings.

TRANSCRIPTION AND ABSTRACTION

The first panel (*The Annunciation*) is centred on a yellow/gold ground reminiscent of the gold-leaf grounds to be found in Byzantine and icon painting. I have played with the concept of haloes as pictorial devices in a number of paintings, and re-state the diagonal striations of yellow (light) emanating from the central shape. In line with a more deliberate image invocation, or in creating a sign for, for example, a head, I have represented the angel in the top left of the canvas.

■ TRANSCRIPTION AND ABSTRACTION

In the second panel (*The Nativity*) the source was of the Madonna and Child; a lot of the incidentals of the original are pared back, with the white ground creating a surface that distances those shapes it covers and throws the repainted shapes forwards. The improvisation within the painting process is to create a new balance in the composition so the painting stands on its own, but also on its own terms.

TRANSCRIPTION AND ABSTRACTION

This panel (*The Crucifixion*) is taken from the alabaster sculpture that shows the crucifix balanced between God's knees. The crucifix is a really difficult image on which to get any visual purchase as it is so immediately iconic. So in this panel I totally underplayed that and allowed it to drift into the ground colour. The two knee shapes interested me a lot in this, and the colour relationship separates these out. The orange to maroon colour means that the white has a role to play in the composition, but I did not want this to disturb the darker tones of the painting.

■ TRANSCRIPTION AND ABSTRACTION

This panel stems from the Ascension. The hole in the top of the painting was a literal translation of the alabaster – these sculptures really are this iconoclastic and playful, and it is just a pity that so much of this cultural history is lost to our current consciousness – where Jesus rises up heavenwards through a sort of skylight.

TRANSCRIPTION AND ABSTRACTION

The final panel (and the final alabaster panel of the Swansea Altarpiece) concerns the Assumption, where Mary is assumed into heavenly glory. The darker tones allow the white to glow out of the muted space, which in turn reflect back the rich, dark tones of the colour used in the rest of the panel.

101

TRANSCRIPTION AND ABSTRACTION

monasteries had not occurred during the Reformation. I am as much interested in this lost culture as the traditional story. The once painted alabaster reliefs are tantalizing glimpses of the particularities of the culture I would have otherwise inherited as an artist of this country and culture. This offers me room to manoeuvre in terms of the pictorial liberties I often take through the 'abstraction' of these narratives. There is a curious freedom to imagine around the metaphysics of these rare artefacts, and I use this to create a new visual structure.

Each of the five panels 'represents' a part of the story of Christ and the Virgin Mary in true Roman Catholic tradition – the Annunciation, the Nativity, the Crucifixion, the Ascension of Christ and finally the Assumption of the Virgin Mary. The visual structures in the painting are derived from study of the original, but in no way am I attempting a transcription. Instead my focus is the ongoing narrative of my own shapes, marks, and more importantly my developing use of colour space.

This work was conceived as five panels hung together so there is interplay across all five. This formal set-up meant that choices in each panel had to be relative to the whole so that rhythms of colours can bounce across the multiple panels. This in turn meant that the composition of each panel functioned in two ways: internal to each and across the whole.

Making a transcription of a work that intrigues you not only offers you the chance to get up close to the artwork in mind, but by making work from it you can challenge your habits as a painter, and learn more about the formal elements of picture space and picture making. You may want to keep this work within your exercises and studies, but I recommend that whenever you study any painting or sculpture you do so by drawing and working with the elements in order to understand what makes great art tick.

Complex Narrative

Now that I had understood a lot of lessons to do with compositional dynamics from the paintings made as transcriptions, I decided to create my own narratives, and they ended up as quite complex.

In the diptych *Complex Narrative* (2010), I have deliberately created a very complex structure to the painting, hence its title. I have tried to explore an idea common in certain pre-Renaissance paintings, rediscovered in Massaccio's frescos – for example *The Tribute Money* – of including more than one 'narrative' within the confines of a single canvas (in my instance across two canvases). The inspiration behind this painting lies in the various Italian paintings depicting *The Baptism, The Betrayal,* and finally *The Pieta*, each a significant episode in the narrative of Jesus' life and death from biblical origins. The idea of using two canvases came to me as a formal possibility of using the pivotal moment of the kiss of betrayal as a visual pivot to the two canvases – the lightness of the story in the left panel, and its darkness in the right panel of the diptych.

As a result I could play with these elements – light side/dark side, daytime/night time, sunshine/halo, happiness/grief, dualities that either find their way into the shapes and collective image of the painting, or not, but the ambition remains. This is still, in my terms, an aspect of play. There are no boundaries to this form of purposeful play – by this I mean the turning around of concepts and prejudices, even those of a heavy or heavily ascribed nature.

TRANSCRIPTION AND ABSTRACTION

Complex Narrative. The painting of this work follows the pattern of the paintings we have looked at so far, except with this painting the fluid veiling of colour across the shapes creates a space that is more directly imposed upon by the final shapes. I tried to use three hues of yellow and three of blue as the underpinning logic to this painting. I have studied the paintings of Matisse where he ruminates on the use of a blue and yellow axis, and the moves in this painting were consciously related to that series of the great man's work. The use of blue as the ground colour was to enable a daytime/night-time contrast between the two panels, so the tonalities in each half pivot around the shapes at the centre join, and the light and dark blue relationships swap over. This again relies on a duality existing within the painting, so that I can bounce the other elements around. The yellow shape in the right-hand panel is a revisit to the *Pieta* forms I have used for a number of years – as discussed in Chapter 6.

CHAPTER 9

THE USE OF STUDIES

We now come to a series of paintings in which I have created a series of signs and symbols that 'stand in' for ideas and values, rather than follow the more rule-orientated practice of depiction. This allows my paintings to continue to explore the colour possibilities within each canvas in a more unrestricted manner. These paintings came about through a project I was involved in called *Re:searching Playing the Archive*. In this particular project we were looking at the Barings Bank archive. Most of the archive, I must admit, passed me by, until those papers relating to the 'Louisiana Purchase' surfaced. I found myself singing (in my head) a song I had heard by Eliza Carthy called 'The Americans have Stolen my True Love away'. I then thought about the 'content' of this purchase, how much land there was, and what was contained in it, and how this could be turned into monetary calculations.

Initially, this seemed to break down into a series of subjects: the American Union flag (or rather its less starred prototype) being generated at this time, the slave ships carrying bought and sold peoples from far-away lands and cultures, tepees containing the native North Americans whose lands were being sold from under their feet, maps that drew limits and arranged frontiers. I could go on, but these were the starting points for, in the first instance, a series of etchings (see *The Currency of Art* published by CCW Graduate School), and then a large series of paintings of very varying sizes.

The Concept of Studies in Making Paintings

At this point it would be appropriate to introduce you to the concept of studies in relation to making abstract paintings. These are an essential part of the development of both pictorial ideas and colour relationships. I hope by showing examples of these you will be able to use this method as a jumping-off point for your own continued development. I have left this topic to this point as I think this group of works best illustrates my own working methods.

As you can see from the group of studies below, ideas/shapes/colours appear and disappear, become prominent or retreat into the background, and all buzzing around signs and symbols of ideas as they begin to form into a cohesive (in my terms) series of pictorial possibilities.

To decode some of the 'imagery' used in these paintings I will demonstrate the prime shape that I consider as the 'ancestral heads'. This can be as simple as a series of three coloured shapes, but comes from the traditional way one would mark out the orginization of the face on a drawing of the head – you would mark across the oval of the head, and the areas where the eyes, the end of the nose and the mouth would be situated. I have used this structure of marks to 'stand in' for a head.

LEFT: *The Americans Have Stolen my True Love Away – Music.*

THE USE OF STUDIES

These little sketches are to demonstrate the origins of the 'head' shape in the paintings below, usually at the top and bottom of the paintings. These offer an example of where a sign for something can be developed (abstracted) from something else – in this case the drawing of a head. When drawing a head, especially for beginners, it is wise to indicate where the eyes, (the bottom of) the nose and the mouth are to be further delineated as the drawing progresses. I have hijacked this scaffolding for my own pictorial purposes. Once this idea of a head has been 'liberated' and expanded upon, it allows further invention around it – in this case in a formalized series of marks to indicate hair. Having abstracted these two elements I can change colour and emphasis at will to play off the other elements in the paintings in which they appear. You will see later that these signs then come under more playful change and development as I use them in the '*Ancestral Voices*' series of paintings. This diversion away from reality, or the 'correct' representation of reality into the abstract realm, allows the paintings to focus on making a rich and varied experience of pictorial space.

The studies below came from contemplating the shipment of people in head-to-toe formation in the holds of the slave ships. There is an ambivalence around these shapes, as in my work I have freed them from the actualities of their plight, so they feel like a signified shape that offers a benign presence in the work – ever-present ghosts from the past, if you will. Within the picture space I am cramming references to tepees, the flag, and a particular shape that symbolizes for me the layering of history that allows, for instance, something so magnificent as jazz music to have emerged from this enforced existence, and the consequent cultural development from uprooted rhythms and instruments to new music on adapted (what we could call) 'classical' instruments. The banjo holds a significant role in these paintings and in American, now world, culture, in that it is an invention from a gourd-like instrument traditional to tribes from Africa, and was directly developed through African heritage into Western instrument-making materials – in other words, a genuine hybrid.

The larger of these paintings basically fell into three types: what I call the slave ship paintings (see picture); the tepee paintings (see picture); and music paintings.

Having spent a lot of time with the red and white stripes of the flag, I think I reacted away from primaries to a palette of earth colours and whitened up colour.

The next image is of a study made after the larger painting above – it is worth noting that making studies of existing paintings also allows you to invent and improvise around any chosen theme. The extra familiarity that the process of making studies of and around paintings recently created, allows for an extension of the life of these formats and structures, and a deepening of your understanding of what our painting space can handle.

In the next chapter we are getting nearer to my current work, one of which is a development of this diptych into a larger format.

THE USE OF STUDIES

The following six studies gradually set out the pictorial structure that I will use in the larger format paintings. Studies in this sense allow me to try out all sorts of pictorial variance and possibilities, and increase a kind of settling-in process to the composition that will sustain me through the main paintings in this group. In fact, all the clues to the paintings below are within these small studies, and the main formats and the crowded pictorial space are set out here. I was not interested in narrowing down possibilities as I have done in my earlier work, more like stirring it all up and seeing what will come about through the experience of making. In other words, vigilant play. Obviously studies allow this in many and varied forms – the emotional investment is not as severe in these small and fluid works, so they feel lighter on their feet, less serious and demanding. They are painted in gouache on paper (then mounted on board in this case) so there are also really quick drying times, which also speeds up the rate of ideas changing and developing. These studies have obviously come from the idea of the exercises, but are more formally part of my everyday painting method.

107

THE USE OF STUDIES

108

THE USE OF STUDIES

■ THE USE OF STUDIES

The next step is to try out ideas on small painting scale (around 9 x 12in) to pick out the bits of the studies that I feel can be utilized in my oil and wax painting methods, so I can see these as pushing the ideas further towards the finished paintings.

THE USE OF STUDIES

These more intermediate-sized paintings (around 18 x 24in) use the same kind of painting tools but smaller. These tools are adapted for the same purposes – smaller brushes and scrapers used in the same way as I would use them in larger form in the large paintings below.

■ THE USE OF STUDIES

In this painting I have developed the three marks declaring face into a distinct series of forms – each can still be variable around the signifying shapes. Collectively they represent a head and hair to me. The slave ships transported people from Africa to the US crammed into the holds so they were manacled head to toe. The heads and feet symbolized this journey in this painting called *The Americans Have Stolen My True Love Away 1* (2011). As described elsewhere, the image I used for the proto union flag was, at the time of the Louisiana Purchase (which started off this series of paintings), a drawing of the projected flag, and included no more than seven stars. The row of heads and the appearance of feet allowed me to be formally free in their delineation – red 'face'/brown 'hair', white 'face'/black 'hair' and so on. This allows me to refine and define the composition through all these disparate and abstracted elements.

The Americans Have Stolen My True Love Away – Teepee. Along with the elements I have just described in its sister painting I added the shape of a tepee, as it occurred to me the native Americans were also bought and sold along with the land in the Louisiana Purchase. The tepee is sketchily entered here but remains the central shape in the painting. There also entered into the paintings an idea about the layering of history between then and now, and this was represented for me in the abstract forms of connected cell-like structures in the middle area of the painting. At this time I also felt that the 'heads' along the top and bottom of the paintings were forming a sort of ancestral chorus to the events in the painting. This idea grows in successive paintings until we get to the final paintings of this series.

■ THE USE OF STUDIES

The Americans Have Stolen My True Love Away – Music. I had used the flag emblem enough by this time, and I wanted to concentrate on the issues less heavily and readily equated (flag = union stars and stripes). In this painting I was musing over the fact that the music I most like was fomented through the strife and impossible difficulties of those people bought and sold as slaves. The music of the twentieth and twenty-first centuries that I most relate to developed out of these impossible conditions and tormented by impossible prejudice after its dissolution. The melting pot of all these circumstances and history developed a form of music that underpins all popular music as far as I can tell. So I wanted to celebrate that. I chose an image taken from a painting of a social event of sorts in a plantation attributed to John Rose, called *The Old Plantation*. I was particularly interested in the gourd-like instrument being played, as we know this as a forerunner of what we call the banjo. This is seen in this beautiful painting next to a drummer, and I used these two figures for the core of my own painting. As usual I have taken extreme liberties in the rendition and the signs around these figures. I am also calling on Picasso's many 'cubist' renditions of musicians. In this sense I can put into this painting an idea of ancestral antecedents (the rows of 'heads'), the compression of time and space (in the layered structures), even something as curious as a loud check suit and grand hat. This is as near as I can get towards depiction, but I resolutely maintain a level of abstraction that brings me closer to the spirit of cubist-type space.

THE USE OF STUDIES

In this painting (*Music – Diptych*) I have returned to the diptych shape of earlier paintings, which allows each panel to be centred around each musician.

CHAPTER 10

INHUMANITIES AND HUMANITIES

I paint the way I do because I can keep on putting more and more things in – like drama, pain, anger, love, a figure, a horse, my ideas of space. It doesn't matter if it differs from mine, as long as it comes from the painting, which has its own integrity and intensity. (Willem de Kooning)

An important rule about abstract painting that probably fits most things is that 'ideas are not one thing, they are many things'.

After finishing the series of paintings that incorporated an abstraction around the American flag and slavery, I became involved with the idea of cultural and moral actions, which I categorized as 'humanities', or its opposite, 'inhumanities', relating this pictorially to those fantastic murals to be found in the great cathedrals in (especially) Italy, which depict the last judgement. These usually depict the worlds into which we ascend or descend after life: Heaven and Hell. In my case I am more concerned with the idea of our actions producing a focus on humanities or inhumanities – though sometimes it is not as simple as all that.

The images and shapes that come into being through the humanities part of this on-going series are (so far) related to the triumph of music and culture, particularly the music related to one of history's grossest inhumanities – slavery.

Inhumanities are like the circles of hell in Dante's Inferno, many and various, and a really long series of work beckons. In the same way that we looked at the way pictorial space changed through cubism, where the focus for abstraction was the drawing of the space, I wanted here to take the complexity of the picture space further following the last set of paintings. My motto became increasingly 'more is more' (intentionally to challenge the minimalist/formalist dictum you may have heard before: 'less is more').

I thought it would be instructive to walk you through as honest a description of a painting's genesis as possible, to relate the thought processes and formal changes that come about from making studies into the finalized painting form. As I said earlier, you will probably find that there are a number of stupid ideas and impulses mixed in here with my pictorial intellect, but I really do believe this is to be expected, as we don't have smart ideas all the time.

Inhumanities

To begin these works I used a tondo shape ('tondo' is a Renaissance term for a circular art work) to get away from a traditional gravity and the rectangular ordering of the pictorial space, where things sit on the ground plane, as using such things as the gateway and creating the Charon character are deeply suggestive of that figuratively orientated pictorial space.

My intention in making this as a large and intentionally cluttered painting was to allow the viewer to pick through the clutter to establish their own narrative to the painting. For me, well used to my own shorthand and extended play around images, this painting is a depiction of the gates of hell – the gates to Auschwitz seem to fit very well with this concept – where the inmates are witnessing/hallucinating watching Charon the demon oarsman of the Styx whipping the cowed souls of the perpetrators of inhumanity into a real hell. The Charon shape dominates the left panel in bold red, the oar shape takes us into the second panel.

The fracturing of the image over more than one canvas has

LEFT: *Charon.*

■ INHUMANITIES AND HUMANITIES

The music painting, *Tondo – Music*, seemed to rescue humanity – eventually – out of the dehumanizing concept of slavery. I equated this humanizing process to the 'heaven' depicted in most Italian churches (of any period), in another standard image to be utilized by artists serving the church – in the subject of the Last Judgement. Here we see depictions of lost souls and the hell that will befall them. The heaven, which has always seemed rather stilted and visually less interesting, was usually about safety and sunlight, the two elements forsaken by those unfortunates going the other way. In these tondos I have tried to represent those two extremes as inhumanities and humanities. In the tondo on the left *(Tondo – Hell)* I have utilized signs and symbols of negative and inhumane actions. The notorious slogan on the gates of Auschwitz – *Arbeit Macht Frei* (or work makes (you) free) – Charon the demon that

118

transports souls to Hades is incorporated, herding the guilty into hell. All this is watched by those who suffered the most, from their bunks imagined in the camp and overseen by our cultural ancestral voices. The colour in this tondo makes for a demonic and blood-red space, contrasted with yellow-haloed, blue and white-striped shapes floating within the picture like abstracted angels. The stacks also make an appearance symbolic of the compression of time, and how this inheritance is part of the fabric of our own culture. The tondo on the left uses lighter-keyed colours in keeping with a lighter mood, and again represents music in the form of our two musicians. This is not so contentious in either a pictorial or ethical sense. Humanities are a much more agreeable subject to ponder over.

INHUMANITIES AND HUMANITIES

These drawings were resolved in the painting in the smaller, left-hand panel of the finished work. I wanted to give Charon a panel and space of his own, and I had in mind that I wanted to be able to separate this panel out from the diptych, so it had to have its own formally resolved picture space, as well as connect to the main pictorial space.

allowed me to utilize multi-canvas arrangements, which further plays with the cubist-derived fractured space. This also allowed a separateness to the painting process, although the image quality, such that it is, can also hold the painting over the spaces between panels.

I have used the Charon image from Michelangelo's *Last Judgement* (my favourite painting of all) many times in my work in the past, sometimes more abstracted than others.

The accompanying illustrations depict a series of very early drawings to establish how I can utilize this form into the kind of paintings I wanted to do around this inhumanities theme. It is worth noting that not all abstract paintings negate any reference to the figure or images of such. Borders between abstraction and figuration are infinitely expandable and contractible. I have never believed in purity – it does not sit well with my personality. So I started off this painting with drawings and studies to find my way into it.

I used further sketches and studies to imagine and work out the 'landscape' of the picture, all the while trying to settle on the pictorial space that would suit my idea.

120

INHUMANITIES AND HUMANITIES

The Charon panel of the painting below – the red forms pick out the demon.

I was also still looking at ideas for the finished painting to be in a tondo shape.

However, for this painting I thought a longer rectangle would be interesting to construct. I also thought that I could possibly develop the cross-panelled approach and try to isolate the 'Charon' figure a little, but lead that image into the rest of the painting through the oar-type shape.

More constructive play ensued, as shown in the following illustrations.

The resultant painting from all these studies, change of mind, and improvisation during the painting process, became an asymmetrical diptych stretching across ten feet (3.04m). The resultant painting is darker than the studies and concentrates on the blue-red axis of the colour spectrum.

As you can see from the colour I was using, the hell-type narrative allowed for non-pastoral use of colour. This in turn offered me access to colour relationships that were not easy or comfortable for me to use, and which I saw as a challenge to my past work.

INHUMANITIES AND HUMANITIES

In these two images and those that follow I was trying to develop a sense of colour appropriate to the ambitions of the painting. I was also trying to maintain an abstracted notion of what was a real space. I was less interested in depicting that reality than challenging my own inherited sense of pictorial space. In trying to see if there is a possibility of a narrative within abstraction I have taken the 'images' in these studies as near as I have ever been to depictive devices: a sense of gravity (pictorial bottom edge), a cinemascope feel to the space, the gateway sign still visible. Of course these are challenged by the ancestral heads idea framing the 'action', so that for me, the heads create a circular idea of space as well as can be seen from the 'to do' studies where the heads surround the action. These float over the pictorial space rather than being situated in it, offering a pictorial counterbalance to the more earthbound renditions of the bunk beds and the signifier of the demon.

INHUMANITIES AND HUMANITIES

■ INHUMANITIES AND HUMANITIES

124

INHUMANITIES AND HUMANITIES

Despite narrowing the gap between what we think of as representation and abstraction, the fomal devices within these paintings offer me the chance to alter the colour focus in each work, within a limited range, so that the roles of certain colours (for example the white and lighter colours) change in intensity to the pictorial space. The use of a coloured ground as mentioned earlier allows a more varied set of roles and spatial positioning within the pictorial space for white. If this was all set within a white space, all of the colours and tones within it would be darker than the ground colour. The beauty of a coloured ground for me is that it allows more tonal variety and colour resonance.

125

INHUMANITIES AND HUMANITIES

The tone of this painting (*Inhumanities – 1*) changed the fiery red of the tondo paintings into a cooler and more subdued blue. In part this is to isolate the Charon figure more as it represents a passage from the left- to the right-hand side of the painting with the red oar cutting its way across the pictorial space. The grey arcs in the 'foreground' represent the hell-bound souls of those that persecuted the inhabitants of this inhuman place. The gateway sign spans the painting and the angel-type forms have now been rejected so that the space has a more forlorn sense to it.

The last painting in this series (*Tondo – Inhumanity*) is this final tondo where I just wanted to re-state the red orientation of the picture space, as red is so suggestive of hell, flames and demonic light. This accentuates the unnaturalness of the space, which suits my purpose in this final work in this series.

Humanities Means Music

In tandem with this 'inhumanities' theme I had to look at the other side of the coin – often the other side of the wall in Italian *Last Judgement* paintings. You see the serpentine dark, and intense colours on the Hell side of the painting or wall, and lighter, safer, calmer colours on the Heaven side. One can take only so much of the darker side of humanity: we also need to see qualities of light and humanity.

I had invested a lot of work into the 'inhumanities' aspect of this work and was enjoying the cluttered space and the flights of fancy around the elements in these paintings. But I was neglecting the other half of the subject of this series of paintings, so retuned to the 'humanities' aspect and the 'heavenly' conundrum of good being safe and slightly boring. So I tried to invest my music paintings with some invention to the pictorial space. I did not have a set of words to plaster across the front of the paintings, or any demons to conjour out of brush marks, but I did have a set of formal devices that I could deploy. The hint of hats, the check suits, banjo and drums – all of these offered a set of rich possibilities with the paint. What they offered was variety within a familiar structure, and these possibilities would bend and challenge any familiar structure, once it had become familiar to me, into 'something else'. The ambition of most artists is for their work to go 'somewhere else' and to be 'something else' that they either inherit (as their cannon) or that they can imagine.

■ INHUMANITIES AND HUMANITIES

I have included these studies so you can get an idea of me getting to grips with the elements as I start to manipulate them: hats, faces, instruments, check suits, all are being checked for their painterly possibilities, and by this I mean how they can extend what I do with the paint, whether it is long sinewy lines, or short stabs of brush marks 'filling' the checks. Then I can better see what these image-like qualities offer me, to expand on what can be done with pictorial space.

128

In this painting (*Music – Diptych 2*), more than any other, I was conscious of a relationship to 'cubist space'. I have always liked the signs and symbols of this kind of space, and how marks can point in two differing directions at the same time. This involves an even more self-conscious structuring of the painting elements and the 'whole', where the flow of pictorial events bounces and echoes across the surface, as indeed how the colour changes its relationship of 'ground' and 'image' so that the combined space is interlocked, rather than easily isolated as earth/sky figure/background dualities. I prefer the involved spaces that abstraction can bring to the table.

If anything, although I still wanted to have a visually cluttered space, I was still very interested in looking again at the kinds of spaces we have seen in cubist-orientated work. So I worked again with the idea of a diptych, as this form has plenty of potential for the pictorial space I was developing. In this version the musicians are less obvious (certainly like the studies), and my concerns were to make a cooler, yet noisy picture.

Of course, once I made a diptych or extended the image over two canvases... what happens when you stretch it over twelve?

Such a fractured surface allows me to investigate (play) with more visceral paint, enjoying the physical nature of the paint. The gaps in the painting allow for the stretching of the medium, letting it crust up over the edges of the panels, emphasizing the tactile nature of the paint – paint as stuff – so that the image is even more dispersed over the surface and in the paint.

■ INHUMANITIES AND HUMANITIES

Maybe because this painting (*Music in Nine*) is based around two seated figures that occupy space in the traditional figurative sense (as can be seen in the drawings/studies), I have more readily taken to splitting up the traditional elements (physically in this painting). The two images stretch across the nine canvases, which increases the sense of abstraction. The paint is full blown in rich oil and intense colours so that the first experience of the painting is of the elements, rather than an immediate sense of the image. This is a very good example of the tension and 'play' I utilize and enjoy between the notion of abstraction and the recognizable. In the breaking up of what would otherwise be an easily digestible pictorial event into an abstraction, it has allowed me and the viewer to look at the elements almost in isolation – the loaded brush marks and the intense colour are experienced aside from their indicative intentions.

INHUMANITIES AND HUMANITIES

I include these two details to try to indicate the way the paint has been loaded on to the surface through brush and squeegee, and squeezed straight from the tube – it was exceedingly enjoyable to paint!

131

CHAPTER 11

WORKING TOWARDS A FINAL SOLUTION…?

Ancestral Voices

In the last few paintings I will look at here, the central images of 'Charon' or the two musicians have gone, and I have re-engaged with what I consider to be the peripheral 'heads' or the shapes that surround the dramas of the last few years' work. In my sentimental way I consider these as 'ancestral voices' that are always ringing in our subconscious. These shapes stand in for our parents' parents, or maybe voices from further back in our collective cultural history. I promise you I am not on drugs, but I am somewhat obsessive and romantic, so please understand these lines within this context.

I am not trying here to be flippant, because this kind of association with metaphorical thinking forms the basis of what I have called in the past the 'studio narrative' of my work. As I have said earlier, when you live with a painting or series of paintings and have a daily interface with them, you are attached to them in differing ways.

I have always anthropomorphized my shapes and pictorial spaces. I think the urge to do so is probably inherent in my cultural thinking – those things that have influenced/astounded/inspired me – because I am of a certain age where these events 'formed' me. It is impossible to choose your point of entry into what we call the art world: you are born into your culture and you have to deal with what you inherit at that point. This is why I stated at the very beginning, there is no point painting like me, you will have to recognize and work with your own inheritance and your own personality.

Whether the shapes I use 'mean' this or are meaningless, the formal arrangement of these shapes and the colours that make up them or the 'background' space has taken over my studio time for the year. I have made a massive series of small studies, studies that started off as black and white, but gradually utilized colour. This is often a ploy of abstract artists, especially when change is on the horizon and they are looking at shapes or the drawing of shapes in a different set-up or space. They often get rid of the distraction of colour so that the 'stage' can be set up for its grand reappearance.

And so in the *Ancestral Voices* series of paintings in the following pages, we start with studies in black and white, then moving on to those in which colour starts to appear, growing in intensity – this might be in lightness or in darkness – until they achieve full-blown saturation and visceral delight.

LEFT: **Study for** *Ancestral Voices*.

WORKING TOWARDS A FINAL SOLUTION...?

An old trick of abstract painters (and in some cases figurative painters too, if we are to look at Rembrandt's methods) when looking at a new configuration, or seeking to develop away from the (now) familiar habits of making, is to work in black and white. In the case of early cubists abstracting from the images at their disposal, we have seen that colour can sometimes get in the way of (or dominate) reviewing and renewing the architecture of pictorial space. So I limited my palette in this way for the early studies of this new and most current series of paintings – *'Ancestral Voices'*. It seemed to me that I was more interested in the formal properties and varieties of possibilities I was achieving with these (sometimes) secondary elements of the previous paintings. So I proceeded to rid the paintings of the other figuratively derived shapes and signs, and to concentrate more fully on these elements, to see what could happen.

WORKING TOWARDS A FINAL SOLUTION...?

As you can see, it wasn't long before I had to start using colour, which changes the intensity of these studies. The black and white shapes become increasingly vibrant when they are painted over another colour (particularly black over a red) or float over the intensity of what lies behind.

■ WORKING TOWARDS A FINAL SOLUTION…?

Obviously another aspect of colour in abstract pictorial space is its ability to contrast and harmonize with lighter and darker tones so that the pictorial space can have a lighter or darker 'feel'. This 'take-over' of the primary pictorial space and previous imperatives is a constant mechanism for a change of mind. It is a vivid demonstration of why artists, and especially those working abstractly, have to have vigilance in their studio habits, to look out for those elements that surprise you and allow you to see things differently.

WORKING TOWARDS A FINAL SOLUTION...?

The interrelation of colour not only arouses surprise at the confluences and divergences, contrasts and harmonies within painting, but (at its best) is the bringer of joy to the work and the experience of it. Sometimes this pleasure is oversold, and often demeaned as merely pretty, or derided in favour of more meaningful content. But the older and more experienced I get, the more I realize how difficult it is to move beyond the pretty and inconsequential use of colour and shape into a world in which these elements stir the spirit. But once beyond the immediate, these stirrings have greater consequence. They allow us to understand the human spirit, as a sort of pathway to its core – and I cannot see a more significant ambition in art-making, or a more important one. And this relates you to all the other happy pilgrims making paintings, so that you become part of this endeavour too. Curiously the more you make, the better you become at recognizing this in all the other paintings and artworks you experience. Learning through making is what we do.

■ WORKING TOWARDS A FINAL SOLUTION...?

These studies were enough to take me on to the larger-scaled paintings with an expansive use of colour at high saturation. Of course there are also more subdued paintings or more tonal paintings, but in the end there is somewhat of a triumph of colour that just lifts your spirit and raises your morale.

These last three paintings have many of the elements you should have come to understand now, the broadly brushed shapes with fully laden brushes – usually large 2–4in (51–102mm) – the scraper pulling thinner paint over the top, and the restatement of each until I am satisfied with their composition and interrelationships.

It must be said that I enjoy the physical side of the painting process, the happy accidents that become features of the next work, the intention compromised by my own physical capabilities of reach and the continuity of the mark being made. As I said in the very beginning, you have to find a way of working that allows your work (and ideas) to 'flow'. This physicality of the paint, matched with the intensity of colour saturation, does it for me.

Ancestral Voices 4. This white version on this theme has the same elements as the other two paintings in this series, but the pictorial space feels completely different.

Ancestral Voices 5. This is a return of sorts to the orange/blue axis of *Pretty Things* (see Chapter 7), but the orange is of a higher key to that painting, as are the tones of blue, looking almost fluorescent in parts. The shapes are useful carriers of colour, and exist in separate layers of space as they jostle in the pictorial space.

Ancestral Voices 6. One last painter's 'trick' can be seen in this work: the mottled white over the blue shapes in the centre bottom of this painting is made by painting white on a sheet of newspaper, then transferring that paint via the newspaper on to the surface of the painting itself. This allows for a sort of non-directional application, and is in fact a very basic form of printing. As you can see, this allows these shapes a different kind of identity to the others, and this can change or even compromise the spatial positioning of the colour in relation to others.

INDEX

A
abstract
 impressionism 91
 pictorial space 136
 sign for 95
 signifiers 95
 elements 112
Accademia Gallery Florence 78, 79, 81, 86
acrylics 71
aerial perspective 14
African heritage 106
alabaster 100, 101
 reliefs 102
 sculpture 99
Albers, Joseph 59, 61
alizarin crimson 69
altarpiece 102, 96
American union flag 105
ancestral;
 antecedents 114
 chorus 113
 heads 105
 voice 119
Ancestral Voices 106, 134
Angel Gabriel 81
anthropomorphic/anthropomorphised 88, 133
Arp, Hans 48, 54
Auschwitz 117, 118
Ayers, Gillian 46

B
background space 135
banjo 106, 114, 127
Barber Institute, Birmingham 95
Barings Bank Archive 105
base colour 76
Beatie, Basil 48
beeswax 71, 72
biomorphic 44, 46, 48
Blue Pieta 81
Bowling, Frank 48
Braque, Georges 15
British Museum 71
Buckley, Stephen 56
Byzantine painting 97, 82

C
Carey, Joyce 88
Carrara marble 78
Carthy, Eliza 105
cerulean blue 69
Charon 92, 117, 118, 121, 126, 133
chevron 21, 22, 23
Christ, Jesus 81, 100, 102
Church of St Peter in Rome 80, 81, 85
circular grid 59
cold wax 72, 79
collage 53, 54, 59
colour
 ground 18, 19, 37, 50
 intensity 70
 space 16, 70
 complementary 70
Complex Narrative 102
compositional
 dynamics 102
 device 61
concentric circles 61
conceptual 33, 53
corpuscle movement 46
cosmological spaces 46
crucifix 99
cubism 15, 27, 30, 53, 117
cubist 31, 41, 56, 60, 114, 117, 129, 134

D
Dada 48
Dante's *Inferno* 79, 117
Davenport, Ian 17
De Kooning, Wilhelm 17, 43, 46, 56, 78, 91, 92, 117
Degas, Edgar 70
Delauney, Robert 59
Delauney, Sonia 59
dense surface 81
de Stael, Nicholas 78
digital 56
diptych 102, 115, 129
dissolution of the monasteries 102
divine proportion 62
drawings and studies 130
drips/dribbles 92
Duchamp, Marcel 29, 30

INDEX

E
East Hampton 91
Egyptian caskets 71
Einstein, Albert 30
El Lissitzki 49
embracing doubt 140
en plain air 70
encaustic 71, 72
expressionism 56
expressionist paintings 91
expressive 69
Fauvism 14, 15
Fauvist/s 14, 15, 16, 33, 56, 70
Fayum portraits 71
Fibonacci 53, 64
Fictional Spaces 82
Florence 78, 81
fool the eye 15
formal
 arrangement 133
 devices 125, 127
 elements 102
Francis Mark 48, 56
Francis, Sam 48
Frankenthaler, Helen 17
Frost, Terry 56, 59, 139

G
Gauguin, Paul 15, 70
gestural/gesture 35, 36, 41, 43, 45, 69, 70, 81, 91, 92, 93, 96, 140
Gioconda, La 13
glazing 64, 72, 78
glazing medium 81
gloss/glossy;
 surface 81
 depth 81
 orange 83
God's knees 99
Golden;
 ratio 62 64
 rectangle 48, 49, 62
 section 49, 62
Gorky, Arshile 37
Gossaert, Jan 95
 Hercules and Deianira 95
gouache 106, 71
gourd-like instruments 114
grid effect 83
grid 53, 54, 55, 56, 59
Gris, Juan 40
ground 83, 92, 96
 image 129
 colour 77, 99, 103
 plane 117
Guston, Philip 91
 Guston's *The Return* 92

H
Hades 92, 118
halo/haloes 97, 102
Hals, Franz 91
happy pilgrim 137, 138
heaven 117, 118
hell 117, 118, 128
Hercules 96
Herron, Patrick 91
Hilton, Roger 46
Hoffman, Hans 15, 49
hot wax 73
hue 16, 22, 69, 70
human
 scale 56
 spirit 137
humanities 117, 118

I
icon painting 97
impasto 70, 78
Impressionism 27, 70
improvisation 98
In Relation To 82
Ingres, Jean-Auguste-Dominique 91
inhumanities 117, 118, 120, 127
intensity 69, 70, 91, 96, 125
 of colour 91, 138
Intertwined formality I 95
Italian
 annunciation paintings 82
 last judgement paintings 127
 painting 81, 102

J
jazz 106, 30
Jimson, Gully 88
Johns, Jasper 59
Judd, Donald 64

K
Kandinsky, Wassily 37
Kelly, Elsworth 17
Klee, Paul 37, 53, 54, 56, 58

L
Lanyon, Peter 37
lapis lazuli 69
Last Judgement 92, 117, 118
learning through making 137
Leonardo da Vinci 13, 62
Leonardo of Pisa 64
Le Witt, Sol 64
Linseed oil 73, 79
Louis Morris 17, 67
Louisiana Purchase 105, 112, 113

M

Madonna and Child 95, 98
Madonna 69, 82
Malevich, Kazimir 49
Manet, Eduard 15, 85, 91
mark making 91
Mary 81, 101
Masaccio 102
Matisse, Henri 15, 70, 103, 139
matt glazes 81
matt surface 81
Matta 37
medium 71, 78, 81
metaphorical imperative 140
methodology 53, 69, 71, 78, 140
Michelangelo 79, 80, 85, 86, 92, 120
 Pieta 78, 81, 85, 86
microbiological 46, 47
minimal 55, 56
Miro, Joan 37, 38
Mitchell, John 67
Mona Lisa 13
Mondrian, Piet 48, 49, 63, 85
Monet Claude 27, 78, 70, 85, 91
Motherwell, Robert 46
Museo dell'opera del Duomo 85
Music 106, 117, 118 119

N

Narrative for RS 82, 93
narrative 102, 117, 122
Native Americans 105, 113
Neoplasticism 49
New York City 91
Newman, Barnett 67
Newtonian certainty 29
Nicholson, Ben 63
Noland, Kenneth 17, 59
non-pastoral use of colour 121
non-traditional manner 75
non-gravitational 37
Northampton Museum and Art Gallery 95
Nude Descending a Staircase 30, 43

O

Olitski, Jules 67
oneness 29, 30

P

painterly/painterliness 38, 41, 42, 43, 46, 47, 53, 83, 96, 128
painting space 81, 82, 106
Palestrina Pieta p 81, 85
performative 93
perspective 11, 13, 15, 27
Phi 49, 53, 62
Picasso, Pablo 9, 15, 40, 78, 85, 114
pictorial
 devices 97
 entity 96
 event 69,129,130
 events 129
 ideas 105
 incident 55
 incident 95
 intellect 117, 140
 liberties 102
 logic 93
 possibilities 105
 purposes 106
 representation 40
 space 11, 13, 14, 15, 27, 30, 33, 35, 45, 50, 78, 81, 82, 106, 117, 120, 122, 125, 126, 128, 129, 134, 138
 structure 21, 53, 69,106
 tension 88, 93
 variance 106
 weight 54 63
picture making 102
picture plane 11, 15, 30, 44, 19, 53
picture space 102
Pieta 78, 80, 86, 102, 103
pixels 56
Pollock, Jackson 43, 46, 56, 92
 Pollock's *Autumn Rhythm* 92
popular music 48
Portrait of Madame Matisse 70
Post-Impressionist 70
Pre-Renaissance 102
Pretty Things 93, 138
primary colours 18, 49, 59, 66
proportion 62
Prussian blue 69, 82, 86, 88
push and pull 15

R

received aesthetic 48
Reformation 102
Reinhardt Ad 40, 41, 56
relative truth/absolute truth 29, 30
Rembrandt Van Rijn 70
 Hendrickje Bathing 91
Renaissance 13, 62, 69, 117
Reverse tonality 96
Re:searching - Playing the Archive 105
Rhondanini Pieta, Milan 85
Richter, Gerhardt 85
Riley, Bridget 17, 56
Roadrunner 82
Robertson, Carol 59
Rockburn, Dorothea 63
Roman Catholic 86
 Catholicism 86
 Catholic tradition 102
Rose, John 114
rose madder 69

INDEX

Rothko, Mark 85, 139
Rubens, Peter Paul 70
rule orientated 105

S
scale 43, 70, 110
scraped or squeegeed 78, 82, 90, 92, 96
scraper 70, 74, 76, 83, 93, 111, 138
Scully, Sean 56
secondary colours 49, 59, 66, 88
secondary tones 88
sense of touch 82
'setting a hare running' 140
Sisley, Alfred 70
skeins of paint 41, 43
slave ship 105, 106, 112
slaves/slavery 114, 117, 118
Son of God 81
Soulages, Pierre 56
Soutine, Chaim 46, 91
spread 81, 82, 83
squeegee 67, 79, 85, 92, 131
 squeegee-like effect 83
 squeegeed 67 78
St Ives 59
stand oil 73
Stella, Frank 17
stripes 23
studies 77, 106, 110, 129, 133, 140
studio narrative 88, 133, 140
Styx 117
Sutton, Trevor 56
Swansea Altarpiece 96, 101

T
tactile 34, 40, 41, 53, 67, 69, 129
and as in:
 nature 92
 objects 88
Tanguy Yves 37
tepee/s 105, 106, 113
Tertiary colours 49, 66, 67, 88
The Acropolis 62
The Americans Have Stolen My True Love Away 105, 112
The Annunciation 81, 97, 102
The Ascension 100, 102
The Assumption 101, 102
There's light and then there's light 95
The Baptism 102
The Betrayal 102
The Crucifixion 102
The Currency of Art 105
The Horse's Mouth 88
The Nativity 102

The Old Plantation 114
The Tribute Money 102
The Virgin and Child with Saint Stephen and Saint Lawrence by Croce, Girolamo 96
theory of joints 91
Theory of Relativity 30
Theosophy 49
Titian 70
tondo 117, 119, 120
transcription 40, 43, 86, 87, 95, 102
transparency 70, 80, 81
transparent 78
 glazes 78
 medium 81
turpentine 72, 79
Tuscany 81

U
ultramarine blue 69
underpainting 78
Union Stars & Stripes 114
Untitled Blue 81
Urban narrative A 81, 83

V
Van Gogh, Vincent 15, 70
veil 77
 of colour 83, 88, 89, 103
 of paint
veil paintings 67
Venetian red 95
Vermeer, Johannes 91
Victoria and Albert Museum 96
vigilance 16, 39, 81, 85, 92, 136, 140
vigilant play 85, 106
Virgin Mary 102
viridian green 69
visceral 82
 delight 133
visual pivot 102

W
watercolour paper 16
watercolours 71
wax 73
and as in;
 colours 75
 enriched paint 77
 paint 76
'wet in wet' 78
Who's Afraid of Red Yellow and Blue 67

Z
Zen 56